Praise for
50 Simple Steps

"The direct impact of our lifestyles on global warming is no longer in question. *50 Simple Steps* is your guidebook for becoming part of the solution, starting today. Well-researched and easy to digest, this book empowers positive action and helps you to act on your good intentions."

—**Greg Horn, Author of** *Living Green:*
A Practical Guide to Simple Sustainability;
Co-founder and CEO of Eco Shoppe;
former CEO of GNC and Garden of Life

"*50 Simple Steps* offers practical, step-by-step advice for 'greening' every part of your life, from the car you drive to the food on your plate. We all need to become Green Patriots, and here's how to do it."

—**Jim Motavalli, Editor of** *E/The Environmental*
Magazine; **Co-author of** *Green Living: The E Magazine*
Handbook for Living Lightly on the Earth

"*50 Simple Steps* lays out a wealth of options and opportunities that anyone can do—at home, at work, in the marketplace, and in the voting booth. Its clear, compelling descriptions and take-action resources make this an indispensable resource for anyone concerned about the future of our families, our communities, and the planet."

—Joel Makower, Executive Editor, GreenBiz.com and ClimateBiz.com; Co-founder, ClimateCounts.org

50 Simple Steps to Save the Earth from Global Warming

By The Green Patriot Working Group

Foreword by R. James Woolsey

Introduction by David Steinman

Freedom Press

Los Angeles, CA

The authors collected facts from various established organizations and
credible websites regarding the quantified effects of the 50 Simple Steps on
atmospheric greenhouse gases. The authors were not able to independently
audit these numbers or calculations, but they referenced their sources.
The authors don't and can't guarantee the results stated in the title;
however, they are optimistic that, cumulatively, the steps presented
in this book will have far-reaching positive effects in the battle of
humans versus global warming.

Cover and book design by Bonnie Lambert

ISBN 978-1-893910-49-2

First Printing
Printed in the United States

Published by Freedom Press
1861 North Topanga Canyon Boulevard
Topanga, CA 90290

Bulk Orders Available: (800) 959-9797

E-mail: info@freedompressonline.com

Environmental Benefits Statement

50 Simple Steps to Save the Earth from Global Warming saved
the following resources by using recycled paper (100% PCW).

Trees	Water	Energy	Solid Waste	Greenhouse Gases
60 fully grown	**21,963** gallons	**42 million** BTUs	**2,820** pounds	**5,291** pounds

Calculations based on research by the Environmental Defense

For our great, great, great,
great grandchildren and beyond.

Acknowledgements

We, the members of the Green Patriot Working Group, have noticed our own lives and attitudes have been very positively affected by working on this book, and we hope that you, the reader, will experience the same. Thank you to all of those people without whom this book would not have been possible, especially Jodey Brown, Randi Clausen, Brittany Davis, Cassandra Glickman, Kim Henderson, Bonnie Lambert, Evan Michael Lowenstein, and Carly Zinderman. Thank you also to our editor Sheila Huettl and our assistant editor Tracy Marcynzsyn.

We'd like to thank the green leaders who have supported us including Greg Horn, Devra Lee Davis, Joel Makower, and Jim Motavalli. Thank you to R. James Woolsey for so graciously agreeing to write our Foreword, and to his assistants Nancy Bonomo and Debbie Willie. Thank you especially to David Steinman for providing inspiration an belief in this important project.

And thank you to every individual, organization, company, and governmental agency that is referenced in this book. Because of your efforts to date and those of thousands of companies and organizations that we didn't have room to mention here, we are convinced that humankind has the desire and the dedication to make the critical difference in our fight against global warming.

—The Green Patriot Working Group
Los Angeles, 2007

Table of Contents

Foreword

E arly in the opening section of this book, the authors set out their definition of what they call "Green Patriotism": "Environmentalism, National Security, and Public Health—Three Victories for the Price of One!"

Exactly. And that is both the strength and the charm of this very practical little book. Although full of useful suggestions about how to make changes in our daily lives that can help us do our part to reduce the risk of climate change, there are several other echoes in these 50 steps. You continually have the feeling that the authors are seeking to help you get involved in something of extraordinary importance.

The risk of climate change alone should be enough to motivate us. Even though critics accurately point out that the earth has seen substantial climate change over the eons before the coming of the industrial age, and there may be greater forces at work than human-produced emissions, it is still reasonable for us all to reduce the degree to which we are loading up the atmosphere with, principally, carbon dioxide. It is as if, as a civilization, we are smoking six packs of cigarettes a day. (Actually, there is some similarity between metastasis in the human body and the potential catastrophic climate change that may be caused by such developments as the rapid melting of the tundra and the resulting accelerated release of dangerously global warming methane.) Yes, climate change occurred before human

industrial emissions, and some human beings got lung cancer before anyone smoked, but it is only common sense for us to reduce or stop smoking in order to reduce the probability of catastrophic changes in our lungs. So too with the ecosphere.

As the authors point out, public health also gives us—in more than a metaphorical sense—ample reason to make some changes in our daily lives. Buying organic and locally grown foods are two recommended steps that serve both the climate-change and health objectives. And so does moving away from the use of gasoline and toward the use of renewable fuels such as ethanol, methanol, butanol, and biodiesel (or renewable diesel, or even plain vegetable oil) for transportation fuel. For example, President Bush's current Ambassador to the European Union, the distinguished attorney (and White House Counsel to the first President Bush) Boyden Gray, has stressed the carcinogenic nature of the exhaust of vehicles running on gasoline. As Gray wrote in a seminal article last year in the *Texas Review of Law and Politics*, this is heavily because the so-called "aromatics" that are used to enhance octane in gasoline are clearly cancer-causing. Renewable fuels such as those suggested here are not.

The authors' third objective is to enhance national security by offering steps that will help move us away from paying so much (as of late 2007, we borrow nearly a billion dollars a day just to import oil) to "unstable, hostile foreign powers." Several of the recommended steps clearly serve this important objective.

And finally, implicit in the recommendations is a fourth objective—to take steps to promote local self-sufficiency. Both Jefferson and Ghandi advocated local self-sufficiency as an important determinant of the way we should manage our lives. The spinning wheel in the middle of the Indian

flag is there to symbolize that, in addition to independence and non-violence, Gandhi placed heavy reliance on the importance of self-sufficiency. In the India of his time, this meant in part that an Indian village should spin its own cotton on spinning wheels rather than ship raw cotton to Britain. Gandhi's point was not to promote mindless autarky but rather to teach that enhanced freedom accompanies local self-sufficiency. Jefferson's point was similar in his extended argument with Hamilton about the future of the American economy. Yeoman farmers who were as self-sufficient as possible would, he felt, be better able to resist tyranny. The technology enabling distributed generation of energy and other steps toward local self-sufficiency may finally be catching up with Ghandi's and Jefferson's ideas and beginning to make possible a modern prosperous life together with a stronger commitment, where it makes economic sense, to local self-reliance.

So, as you leaf through this most enjoyable book, surf the very useful listed websites, and begin to make a series of small, but collectively important, changes in what you buy and how you live (latex, not mylar, balloons for your son's or daughter's birthday party, please), you will be doing more than may at first be apparent. People are beginning to understand that steps such as these 50 are about a lot more than one positive objective, even one as important as reducing the risk of climate change. They are about a very substantial, literally vital movement that can give us all a chance to help our civilization swerve away from several serious dangers and toward a much brighter future.

—R. James Woolsey
Former Director of Central Intelligence

Introduction

Today's environmental scientists concur that the activities of many of the 6.6 billion humans on earth are contributing to the warming of our planetary climate. As a result of this global warming trend, catastrophic events are forecasted—events that would definitely ruin your day, maybe even your life, your children's lives, and their children's lives too, if we make it that far.

Indeed, increased temperatures paint a potentially bleak future for our planet. Scientists predict that as the glaciers continue to melt, resulting rising water levels will cause global flooding of low-lying lands, displacing millions of people and forcing mass migratory shifts. The subsequent competition for land and natural resources, often across national boundaries, would likely cause tremendous social upheaval, possibly triggering cultural and religious warring or even genocide in more vulnerable regions of the world.

The foreseeable struggle for resources would also bring America's borders under siege, and our resources would be tapped to the limit as we battled with other nations for the last of the world's precious oil supplies.

Fortunately this bleak forecast is not inevitable. We can take many actions today to avert global catastrophe. It all starts with you. You can be part of this tremendously important global change if you become involved. Each of us is important. Each individual holds the power to change the world.

We are the leaders. We are the pivotal generation of environmental action who will join in unity of purpose to make a powerful difference and bring hope and healing, one simple step at a time. There are so many things we can do today to avert global catastrophe and protect our cherished planet.

It is crucial that we take the steps necessary to respond intelligently to the global warming crisis. When we take these actions to combat global warming, we'll find they have all sorts of other side benefits. That is because a smart, green response will provide many other social and economic rewards including improvements in public health, better jobs, growth of new markets, and new opportunities. The green revolution is the modern day gold rush, but it will bring far more than just economic wealth.

Environmentalist and actor Ed Begley, Jr. says when it comes to going green, be sure "to pick the low-lying fruit first." That's what this book is all about. By incorporating any (or all) of these simple ideas that anybody can do, you will help put us on the road to planetary recovery.

You may already be taking some of the simplest steps discussed in this book, such as shopping for organic food and green household cleaning products. Other choices you make, like your mode of transportation, can represent even bigger rewards when you make conscious, earth-friendly purchases on those big-ticket items.

All of these 50 simple steps offer practical solutions for fighting global warming that are easy enough for any of us to implement. Taking one step at a time right now will start you on the road to being a better person, citizen, parent, and friend. You will also help to avert the greatest global catastrophe since Noah built the ark.

Along the way, your health will improve and you might even start to feel better about your life—like you are living more authentically and in tune with your values.

There is a saying, "We can change the world one light bulb at a time." The trouble is that many of us keep looking at the big picture but won't spend a few extra dollars for a compact fluorescent light bulb.

A trip to any supermarket today reveals carts loaded with junk foods, rather than healthy organic products. Truth be told, while the amount of organic foods Americans are purchasing is on the rise, organics haven't actually penetrated most people's shopping carts. That's why we say this is a modern gold rush. In terms of economics, every 1 percent increase of new organic foods or other environmentally friendly products purchased by Green Patriot shoppers will represent billions of dollars in the new green economy. Even people who are skeptical about global warming have to admit that doing something good to reduce America's dependency on foreign oil is, nonetheless, patriotic—and that kind of Green Patriot environmentalism is what we need to make the difference.

Are you an environmental slob? Join the club! Most of us are. You're the best candidate. Reading this book can shape you up and ship you out as a fit 50-simple green stepper. Even I can do it—and I am a notorious environmental wannabe.

This movement has a big tent though and welcomes all—anybody on the road to the Big Green is welcome here—even if you stumbled on this road by happenstance—even if you're just curious. You can go inside the Big Green and get your own take on why this stuff is important, no matter what you believe.

Anybody here speak eco-Chinese? We need to send this simple message globally.

The Big Green also goes with God. Taking the *50 Simple Steps* is like having 50 Godly virtues to live by.

We can all unite in the fight to save our earth from the effects of global warming.

Joining with our fellow citizens to stop global warming is a chance for the world to come together in one consciousness, united in purpose and intelligence for once. We present *50 Simple Steps* as a solution to our environmental crisis—it all starts with you. Take that first step. You will never look back!

—David Steinman
Author, *Safe Trip to Eden: Ten Steps to Save Planet Earth from the Global Warming Meltdown*

Frequently Asked Questions and Answers

1. What Is Global Warming?
Did We Cause It?

By definition, global warming is the increase of average temperatures on the earth's surface, calculated annually from measurements taken across the entire globe. Scientists attribute the recent rise in average global temperatures to an increase in greenhouse gases (GHGs), which create the "greenhouse effect" of trapping heat from the sun in our atmosphere. These gases include water vapor, carbon dioxide (CO_2), methane, nitrous oxide, and chlorofluorocarbons (CFCs), among others. While the greenhouse effect is essential for life on earth—without it, surface temperatures would be about -2°F—excessive greenhouse gases can also elevate temperatures above the livability range.

Scientific evidence positively links a variety of human activities in our modern industrial age to the increase of greenhouse gases present in our atmosphere. We have seen an overall average temperature increase of about 1.7°F since 1850 and a rise of about 1°F since the mid-1970s. These temperature increases correspond with rises in CO_2 concentration over the same time period and appear to have occurred in connection with the industrial revolution and the recent rapid growth of technology, considering that temperatures apparently were relatively stable for about two thousand years prior (according to the Environmental Protection Agency [EPA]).

While an average increase of 1°F may not seem significant, each degree change in temperature actually has profound effects on our environment when you consider that at the height of the last Ice Age, the temperature was only 7 degrees colder than it is today, and much of North America was covered by glaciers. Every 1 degree increase contributes to the rapidly melting glaciers, rising water levels, and increased intensity and frequency of storms (such as thunderstorms, hail events, and tornadoes), which are worsened by heat-induced evaporation and precipitation.

Looking to the future can be frightening. According to the Intergovernmental Panel on Climate Change, established by the United Nations, global surface temperatures are likely to increase somewhere between 2.5°F and 10.5°F by 2100, and sea levels are projected to rise 0.1 to 0.9 meters over the same period. The most negative predictions foretell catastrophic weather events and sea-level escalation on a grand scale, which could wipe out major cities across the globe.

Before humans came into the picture, the production of greenhouse gases in the atmosphere occurred naturally from sources such as photosynthesis and decaying organic matter. However, man began to add significantly to the quantity of atmospheric greenhouse gases at the emergence of the Industrial Revolution, by burning fossil fuels—such as petroleum, coal, and natural gas—by cutting down forests, and by raising vast numbers of livestock using methods that produce methane gas, one of the most damaging greenhouse vapors. With over 6.6 billion people on the planet, we have been burning quite a bit of fossil fuels and eating too many flame broilers!

2. Is There a Solution? *Can We Really Make a Difference?*

D espite the bleak predictions that many scientists are describing, yes, there is still a way out! There are many actions we can take today to reduce the amount of greenhouse gases we produce and to help avert global catastrophe. History shows us that we can make a difference in reversing man-made environmental crises. We can look to our past successes for proof that humans can effect profound changes in our natural world.

RECOVERY OF THE OZONE LAYER

Since 1980, there had been a steady decline—about 4 percent per decade—in the total amount of ozone in the Earth's stratosphere, and a much larger seasonal decrease in stratospheric ozone over the Earth's polar regions during the same period. Stratospheric ozone protects life on earth from the sun's damaging UVB rays, and its decrease has meant an increase in melanoma skin cancer, cataracts, and impaired immune systems, as well as crop damage and probable plankton destruction. In 1973, scientists discovered that the major source of the problem was chlorofluorocarbon (CFC) compounds—also known as freons—which were used in many industrial, commercial, and household applications, including aerosol sprays and coolant for refrigerators and air conditioners.

When the media released the news about the diminishing ozone layer, there was tremendous public reaction, including consumer boycotts on aerosol sprays containing CFCs, and various government- and industry-led regulations. In 1985, an actual hole in the ozone layer was reported, and this led to 43 nations (including the United States) signing the 1987 Montreal Protocol, which

placed limits on the production and use of CFCs. Today, 191 nations have signed the Protocol, and as a result, atmospheric levels of CFCs have drastically decreased. In fact, scientists predict that the ozone layer will experience a detectable recovery by 2024 and will recover to pre-1980 levels as early as 2050.

REVERSING AIR POLLUTION

Another example of the power of many individuals who are passionate about environmental issues was reported in 2007. The health effects of pollution have been a concern for many decades, particularly in large cities. The Clean Air Act of 1963 and the Federal Clean Air Act Amendment of 1970 were responses to strong public concern. They established that the EPA would regulate national air quality standards for six key pollutants, including nitrogen dioxide, ozone (which is helpful in the upper atmosphere but harmful to breathe), sulfur dioxide, particulate matter, and lead. In April of 2007, the EPA reported on the tremendous success of their efforts. Between 1970 and 2006, the levels of these key pollutants dropped by 54 percent due to reduced emissions from tailpipes and smokestacks. This is especially impressive, as during the same time period the U.S. population grew by 46 percent, energy consumption increased by 49 percent, and vehicle miles traveled in the U.S. increased by 177 percent. Imagine the difference we can make as more of us voluntarily make greener choices, in addition to the businesses that are regulated to do so!

Both of these environmental victories happened because of a public outcry in response to a major environmental crisis, which led to voluntary individual action as well as governmental regulations established to correct the problem. The cumulative effect of individuals, companies, and the government working together made a real difference.

Today, with the problem of global warming, we are looking at a similar challenge to make changes in our own lives and to vote for representatives who will strive to deliver our greener vision and make sure that industry participates in the solution as well.

3. But I'm Just One Person. *Why Should I Participate?*

Let's face it—being an environmentalist and contributing to the solution is the right thing to do, and it will genuinely make you feel good about yourself! Many people find that taking care of the environment also brings a new dimension to their relationship with God.

Bill Maher has said, "I don't know a parent of a five-year-old today who can look their kid in the eyes and not care about the environment." Each one of us owes it to our children and grandchildren to do something, even as our ancestors fought for us to have the freedom and opportunities we have today. Let's be heroes to our future generations.

The U.S. is creating the lion's share of the problem by producing GHGs at a much faster rate than the rest of the world's population. So the actions we take to reduce our carbon emissions have an increased impact—both environmentally and financially. By reducing their carbon footprint, each person in America can positively impact the environment to a greater degree than can many more people in less-developed nations whose footprints were much smaller to begin with. Take advantage of this opportunity to take positive green actions that will equal the efforts of many people overseas!

And don't worry that you might be the only person taking action. Everywhere you look today, Americans are

hungry to solve these big issues and to prevent the potential catastrophic events that would greatly affect our lives and those of the next seven generations. In 2008, many Americans have the climate crisis on their minds. According to a March 2007 MSNBC poll, 86 percent of Americans believe global warming is a critical or important threat, and according to an April 2007 ABC News/ *The Washington Post*/Stanford University poll, 80 percent of Americans say they are willing to make changes in their lives to help the environment, even if it means personal inconvenience. When you take green actions and allow others to see them, not only are you a hero to everyone who shares your environmental values, but you have made it that much easier for people around you to follow your lead and that much harder for them to continue in denial of the problem.

4. What Is Green Patriotism?
Environmentalism, National Security, and Public Health—Three Victories for the Price of One!

Green Patriots are patriotic Americans, across party lines, who love the United States and understand that we can create a safer, more secure future for our nation by protecting our environment and reducing our dependence upon foreign oil. As you will see in the following chapters, by luck or design, when we take the steps to combat global warming, in most cases we are also strengthening public health and our national security. The benefits of reducing petroleum by-products and petrochemicals in pesticides, food, plastics, personal care products, furnishings, and much more include fewer incidents of cancer, better health, improved national security, and less money paid to unstable

hostile foreign powers for oil. As Green Patriot environmentalists, we also understand that the green lifestyle and shopping choices that we make, collectively, will strengthen and reward responsible green companies and can convince environmentally irresponsible companies to reduce their carbon emissions to reasonable levels or disappear like the dinosaurs.

5. What Do I Need to Begin? ## *When Can I Start?*

Now that you have *50 Simple Steps to Save the Earth from Global Warming*, you have all of the information you need to begin to make a real impact on the planet. *50 Simple Steps* is a how-to guide organized in a fun, easy-to-read format. Some of the steps may surprise you, and many will actually be fun to implement. Each step is a simple way you can help fight against global warming and feel good about being a part of the solution.

There's no time to begin like the present! Perhaps this evening you could begin by turning off a light you aren't using or by buying some organic chocolate—and you might also discover it tastes terrific and gets you extra points with your significant other. It's actually quite easy to be a part of the solution. We predict that you will start noticing rewards right away, perhaps in your self-esteem, your sense of purpose, and your feeling of connection to our planet. The global rewards will follow for you and for all of us. Remember that every journey begins with a single step. So go ahead and take yours! Beginning today will bring us closer to our future: a greener world for everyone to enjoy.

6. I'm an Overachiever. *What About Me?*

We knew there were some overachievers out there! If you are feeling ambitious, we suggest that you create a **Personal Green Strategy** by first assessing your current energy use and then applying what you learn in *50 Simple Steps* to design an action plan to manage the amount of greenhouse gases that you generate each day. Your Personal Green Strategy might include one or more of the following:

- A personal daily carbon inventory and action plan
- A personal transportation carbon inventory and action plan
- A household carbon inventory and action plan (a team project for your family or household)
- A carbon inventory and action plan for your workplace
- A carbon inventory and action plan for your school
- A carbon inventory and action plan for your clubhouse or place of worship

Here are some other tips:

- **Work with others.** Green activities are often more fun, interesting, and productive when done with others. The more people you collaborate with—such as your family, coworkers, or classmates—the greater your total impact will be.
- **Get creative, experiment, and have fun.** For example, try a Low-Carbon Family Night—ditch the electricity for an evening, pretend you are living in the early 1800s—tell stories, play games, make music, and do things that families did before radio, television, and electricity were invented.
- **Tell people what you are up to.** If you're working on a green project solo, tell a friend about it, and ask what

they are doing for the planet. It can be a fun topic of conversation with long distance relatives or friends to talk about the green endeavors your family is undertaking and to hear what they are doing in other parts of the country. Remember the primary goal is to encourage, congratulate, and inspire each other. However, if some healthy competition emerges, that may add to everyone's motivation and fun as well.

- **Reward yourself and others.** Don't hesitate to reward yourself for all of your hard work on behalf of the planet. For example, you might want to buy yourself an especially nice bike to enjoy your green commute. It will remind you of all the money you have saved by reducing your energy use and going green. Business owners and managers can also find creative ways to reward employees for their green actions (such as carpooling), and perhaps arrange friendly competitions with other departments for group prizes such as an organic coffee machine or a small plant for each employee's desk.
- **Create an "Eco-Star Chart."** Families (and other groups) may want to create a *50 Simple Steps* eco-star chart to track their successes and reward themselves for achieving green goals. The easiest way to do this is to simply convert a standard wall calendar into an Eco-Calendar by affixing one or more shiny star stickers each day that you or your family does something good for the environment. By the end of the first month, the calendar will likely be covered with colorful shiny stars, and children will proudly explain its purpose to friends and neighbors who ask what it is for. You may also want to establish specific goals and green rewards. For example, as a family you may decide that after

taking 15 green actions, you will buy a fruit tree for your yard and plant it together. Or after taking 50 green actions you will treat yourselves to a family camping trip.

Remember that these 50 steps are only a starting point. Once you get into the Green Groove, there's no limit to the fun and imaginative ways you'll find to enhance your life and preserve the planet by going green.

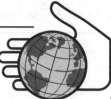

STEP #1
Determine Your
Carbon Footprint

Your "carbon footprint" represents the effect that you (or your family, organization, or business) have on the climate in terms of the amount of greenhouse gases you produce (usually measured in units of carbon dioxide).

Taking a carbon inventory is very important, because solving the global warming crisis first requires you to know how you are contributing to accelerating climate change. Armed with this information you can more readily take effective action to shrink or neutralize your carbon footprint and minimize your personal impact on global warming. Fortunately, there are many ways to reduce the size of your footprint, as well as a number of worthy organizations that can help you to offset it.

Most likely, every day you are creating carbon emissions by using energy generated from non-renewable resources such as coal, oil, and natural gas. Common daily examples include heating and cooling your home and office, turning on lights, using electrical appliances, watching television, and driving. Even when you go to the gym or hair salon, you are leaving a carbon footprint.

You also generate carbon emissions indirectly when you purchase consumer products such as food, clothing, cosmetics, and household products. Carbon dioxide is created in the production of most manufactured goods, and when products are imported or transported long distances, their carbon contribution is even greater. Deforestation also increases levels of carbon dioxide in the atmosphere, because

there are fewer trees to convert the carbon dioxide into oxygen. Therefore, when you purchase wood or paper products from non-sustainable forests, or when you buy food that was grown where forests were cleared to make room for crops or grazing, this adds to your carbon footprint as well.

According to calculations based on data from the U.S. Department of Energy, the EPA, and the Energy Information Administration, an average American 2-person household generates about 41,500 pounds of carbon dioxide each year. It's probably no surprise that Americans account for almost one quarter of all of the world's energy use! While we are behind several countries in per capita emissions, the U.S. far surpasses most of the rest of the world. Now that we are aware of this, we can reverse this pattern and join with other nations that have been more conscientious about their national footprint.

The easiest way to determine your personal carbon emissions count is to use one of the online carbon calculators found on carbon offset sites such as www.safeclimate.net and www.carbonfund.org.

You will need your energy bills and knowledge of your approximate annual mileage for ground and air transportation. These sites will calculate your carbon footprint in terms of your home energy use and transportation, which are the easiest areas to measure. You can expect to be asked for information regarding the following:

- Annual ground travel miles (car, bus, train)
- Annual air travel miles
- Number in your household
- Electricity usage
- Green power usage
- Natural gas usage
- Heating oil usage
- Propane usage

While this will give you a good approximate total, determining your actual carbon footprint in terms of the products you purchase is certainly more challenging.

According to SafeClimate.net, the monthly average footprint per person in the United States is about 1,521 pounds, resulting from transportation and home energy emissions. However, this calculation represents only about 40 percent of a person's total emissions, so you can multiply this by 2.5 to determine your approximate total carbon footprint.

Indeed, the choices you make when shopping for food, cosmetics, household products, and cleaning supplies, as well as your lifestyle choices are also as critical as the car you drive and your energy-use choices at home.

Some organizations such as CarbonCounted in Canada and The Carbon Trust in the UK are helping businesses to communicate their carbon impact to consumers by including a carbon product label, which quantifies the carbon emissions created from the processing of each particular product. CarbonFund in the U.S. has created a CarbonFree™ Certified Product label that will help consumers identify products that have been balanced with energy offsets.

Once you've estimated your own carbon footprint, there are a lot of easy things you can do to reduce or offset its impact. For many great ideas about how to do this, we recommend that you read the rest of this book.

Resources

- www.carboncounted.com
- www.carbonfund.org
- www.carbonneutral.com
- www.carbontrust.co.uk
- www.safeclimate.net

STEP #2
Check Your
Tire Pressure

One of the most simple and effective steps you can take to prevent global warming is super easy: just keep your automobile's tires properly inflated.

According to the American Automobile Association, about 80 percent of cars on the road have one or more tires under-inflated. "Under-inflated tires can cut fuel economy by up to 2 percent per pound of pressure below the recommended level," said the Auto Club's Principal Automotive Engineer Steve Mazor. Basically, when tires are under-inflated, they require more power (and thus more fuel) to rotate.

Properly inflated tires are safer and last longer, too, so preserving them will also be good for your budget. In addition to decreasing fuel economy, under-inflated tires cause imprecise handling and premature wear at the edges of their tread, and they can overheat and fail at highway speeds. On the other hand, over-inflated tires cause a rougher ride and premature wear at the center of their tread.

Tires typically lose about one pound or 2 percent of air pressure per month with normal driving (especially after hitting pot holes or curbs), permeation, and seasonal changes in temperature. Tires actually lose or gain a pound of pressure with every 10-degree change in outside temperature, and additional changes can result due to altitude. It is every driver's responsibility to monitor and ensure correct tire pressure.

Your simple task is this: Check the pressure of your tires (including the spare) when the tires are still cold and haven't been warmed up by driving. Adjusting your tire pressure takes less than a minute per tire and is an easy and empowering way to reduce global warming. Visit one of the many gas stations with pressurized air pumps for filling tires, and begin:

- First determine your target inflation pressure number (in pounds), as recommended in your car owner's manual or from the tire information label that may be located in your glove box, on your doorjamb, inside your fuel door, or on the underside of your trunk's lid. (Note: the inflation pressure number indicated on the tire's sidewall may not be the correct pressure for your car.)
- Simply unscrew the plastic cap from the tire's air valve, insert the air gauge into the valve, and check the current pressure.
- Add air by squeezing the lever on the air hose while holding it firmly in the tire's air valve.
- Remove air by releasing the lever and pushing on the needle located in the tire's air valve. A hissing sound, along with the pressure gauge reading, will let you know air is being released.
- Replace the cap on the air valve once the gauge indicates the tire is properly inflated.

And you're done! Get into the habit of checking and adjusting your tire pressure at least once a month. This step is so simple you might forget it, but don't. You can also purchase an inexpensive tire pressure gauge to check your tire pressure at home. If we all take this simple step, we will make a significant impact and will increase our gas mileage by around 3.3 percent, saving many thousands of barrels of

oil daily, which means fewer greenhouse gas emissions will be turning up the global heat.

Car manufacturers and legislators, now aware of the importance of correct tire pressure, are making it even easier for consumers to keep an eye on their tires' air pressure. Several new cars such as the Cadillac SRX and Jeep Liberty include built-in tire pressure sensors that allow for all four tire pressures to be read simultaneously from inside the car.

The National Highway Traffic Safety Administration has also passed legislation that requires all new passenger vehicles to be equipped with tire pressure monitoring systems in 2008. The legislation doesn't go far enough, as it only requires the monitor to notify the driver when a tire is under-inflated by 25 percent below the recommended level; however, it is definitely a step in the right direction.

Resources

- www.aaa.com
- www.nhtsa.dot.gov
- www.trustmymechanic.com

STEP #3
Change Your
Lighting

If every home in America took the Energy Star® "Change a Light" pledge to replace at least one standard light bulb in their home with an Energy Star-qualified compact fluorescent light (CFL) bulb, "we would save enough energy to light more than 3 million homes for a year, save more than $600 million in annual energy costs, and prevent greenhouse gases equivalent to the emissions of more than 800,000 cars," according to Energy Star, the joint program of the U.S. Department of Energy and the EPA that was created to help consumers save money and protect the environment by using energy-efficient products.

Simply changing a light bulb saves energy, time, and money, reducing significant amounts of GHGs from entering the atmosphere, while leaving more money in your pocket. CFLs last ten times longer than incandescent light bulbs, produce about 75 percent less heat, and use two-thirds less energy. A 13-watt CFL will outlast and use less energy than a 60-watt incandescent bulb, saving you about $30 in energy costs over the life of the bulb. As lighting accounts for close to 20 percent of the average home's electric bill, the savings from choosing CFLs really add up, financially and environmentally.

Available in all shapes and sizes, CFLs perform best in fixtures with airflow, such as table and floor lamps. A reflector rather than a spiral CFL is better for recessed fixtures, as it more evenly distributes the light, according to Energy Star.

CFLs are also available for dimmer or three-way switch lighting. Energy Star recommends installing qualified CFLs first in fixtures that are used at least 15 minutes at a time or several hours per day.

As CFLs contain about 5 milligrams of mercury sealed within the glass tubing—roughly equivalent to the amount that would cover the tip of a ballpoint pen—they should be handled carefully and disposed of correctly. (CFLs still use less mercury on a net basis than incandescent bulbs.)

Many manufacturers are taking steps to reduce the amount of mercury used in their fluorescent lighting products, thanks to technology advances and a commitment from the members of the National Electrical Manufacturers Association.

The EPA recommends that consumers recycle CFLs and is working with CFL manufacturers and major U.S. retailers to expand disposal options. Go to www.lamprecycle.org and click on "State Lamp Recycling Regulations & Contacts" to identify local recycling options. If your state permits you to put used or broken CFLs in the garbage, seal the CFL in two plastic bags and put into the outside trash. Do not dispose of CFLs in an incinerator.

What are other ways to green your lighting? Buy lights with timers (the only energy-efficient way to keep your house looking lived-in while you're on vacation) and motion sensors (a great alternative to keeping exterior home lights burning all night long). You can also provide attractive exterior night lighting with solar lights that power up during the day.

Use as much natural light as possible during the day, even if you must go to another room to complete a task. Also put a stop to empty-room lighting by turning off lights when you leave a room. The next person who enters

can find the light switch, and they may even follow your example.

Spend a little extra effort to change your lighting strategy and you will reduce your carbon footprint, while saving considerably on your energy bill as well!

Resources

- www.bulbs.com
- www.energystar.gov
- www.greenlightsusa.com
- www.lamprecycle.org

STEP #4
Go Vegetarian
for a Day

Substituting salad for steak once a week can mean better health for you and your environment—especially when it comes to global warming. Despite carbon dioxide's bad rap in the global warming crisis, other gases, such as methane, also deserve much of the blame.

Contributing more to global warming than all of the other non-CO_2 greenhouse gases combined, methane is 21 times more devastating as a greenhouse gas than CO_2, according to EarthSave, an organization founded by the author of *Diet for a New America*, John Robbins. Over 50 percent of methane is produced by human activity, according to a United Nations report, and of this, 37 percent of atmospheric methane is generated by animal agriculture (in particular from cows, pigs, and chickens).

With the growth in meat consumption worldwide, methane levels in our atmosphere are rising at rates faster than those of CO_2, but the good news is that methane only remains in the environment for about 10 years versus carbon dioxide's 100 years, so taking steps to lower methane emissions will impact greenhouse gas counts even faster. The fastest way to a solution to global warming could be through our stomachs!

Other human-influenced sources of methane include rice cultivation, biomass burning, oil and gas, coal, landfills, and sewage. Especially culpable are the man-made

methane-emitting wetlands created to store untreated farm animal waste, as well as the deforestation practices common in the animal agriculture industry (clearing forests to make room for grazing land, which also results in more CO_2).

Responsible for more than 100 million tons of methane a year, animal agriculture's effect on our environment is directly tied to the choices we make. If we all decide to change our diets by eating less meat and more protein alternatives, we are taking steps toward a solution to global warming.

It's easy to reverse the 50-year trend of rising global meat consumption by simply choosing to eat less meat. Even if we select a vegetarian meal only once each day or once each week, our collective small efforts will add up to massive methane reduction in our world.

Fortunately, vegetarian protein products abound in today's marketplace, with tofu hotdogs, soy chicken tenders, and an array of meat alternatives (including nuts and beans) available in just about every grocery store.

Dining out presents another opportunity to enjoy vegetarian fare; you can find vegetarian restaurants in every major city throughout the world. A word of caution, though: A Major League Baseball game may not be the best place to enact your vegetarian agenda!

Resources

- www.earthsave.org
- www.happycow.com
- www.vegdining.com
- www.vegetarian-restaurants.net

STEP #5
Buy Organic Foods

Choosing organic foods supports sustainable agriculture while increasing the demand for foods grown without pesticides or artificial fertilizers. Organic farmers take care to produce food in the healthiest manner possible, nourishing their soil, rather than depleting it with the chemical fertilizers and pesticides, as used by many non-organic farmers. The result is not only good for your body, it's excellent for the environment, as organic farming reduces the amount of CO_2 in the atmosphere and that means less global warming!

"Organic farming is a viable part of the solution to global warming," says Anthony Rodale, chairman of the Rodale Institute, referring to the results of a 23-year study by the non-profit educational and research organization that focuses on finding agricultural solutions to major health and environmental problems. The study showed that organic soils absorbed more carbon from the atmosphere than did non-organic soils.

"Soluble nitrogen fertilizers rapidly decay organic matter, thus releasing carbon into the atmosphere instead of retaining it in the soil system," explains the study. Organic soil also contains microbes that produce "glomalin," a gluey substance that keeps carbon in the soil and out of the air.

The study showed that soil that had been organic for 23 years had 15 to 28 percent greater carbon content than soil tainted with pesticides and chemical fertilizers. The organic

soil captured about 1,000 pounds of carbon and 3,500 pounds of carbon dioxide per acre-foot annually.

The collective effect of 10,000 medium-sized farms converting to organic production in the United States would store enough carbon in the soil to equal the effects of eliminating more than one million cars from the road. With the average car emitting some 10,000 pounds of carbon dioxide a year, that's a lot of CO_2 removed from our atmosphere.

Further study findings reveal even more impressive statistics:

- 160 million acres—all of the conventional corn and soybean land in the United States—going organic would equal 58.7 million cars taken off of the road (25 percent of the total national fleet).
- 431 million acres—all of the cropland in the United States—going organic would equal more than 158 milllion cars taken off the road (more than half the national fleet).
- Converting the U.S.'s 160 million corn and soybean acres to organic production would sequester enough carbon to satisfy 73 percent of the Kyoto Protocol targets for CO_2 reduction in the U.S.

Fortunately, the environmental benefits of organic farming do not necessarily come with a hefty price tag, as organic foods are moving closer and closer to the cost of conventional foods. A shopping survey by a reporter at *The Doctors' Prescription for Healthy Living* comparing 43 similar organic vs. non-organic food prices revealed a marginal price difference overall.

"On many items, the price difference was negligible (one pound of organic spaghetti was $1.29 compared to $1.19 for non-organic), or the organic item was actually cheaper; for example, a 10-ounce box of Cheerios was

$3.79, while a 10-ounce box of New Morning Organic Oatios was only $2.69!"

Sticking to a budget on organics is not hard to do, with health food stores and outlets like Trader Joe's stocking organic foods at comparable pricing to their non-organic counterparts sold in the big chain supermarkets. Local farmers' markets support organic farmers and provide another venue for buying seasonal organic produce at great prices.

Buying organic produce in season is also important, as produce that is not in season locally has to travel a long distance to get to your table.

Buying organic food is easier than ever, making it a truly "simple" (yet amazingly effective) step towards stomping out global warming.

Resources

- www.organicconsumers.org
- www.organic.org
- www.rodaleinstitute.org

STEP #6
Buy Locally
Grown Foods

Buying locally grown fresh foods is a lot easier than you might think, and the prices are often competitive with conventionally distributed crops. While it may not be easy to find all of your favorite foods locally, your extra efforts will be worthwhile to the health of our planet.

The thought of fresh Chilean grapes may be exotic and enticing during a bleak New York winter, but the transportation cost in terms of greenhouse gas emissions is extremely high—and truly bad for the environment. By buying locally produced foods, you reduce our global dependency on the jet fuel used to fly so many perishables around the world.

Referred to as "food miles," the distances foods are transported have steadily increased during the past 10 years and play a big part in effecting climate change by increasing traffic congestion, car accidents, and pollution, equaling more greenhouse gas emissions. When you buy locally produced organic foods, here's what you get in exchange:

- **Fresher, more nutritious food.** Locally grown fruits and vegetables are usually harvested within 24 hours of being purchased by the consumer. Produce picked at the height of freshness tastes better and is more nutritionally complete. Nutritional value declines, often dramatically, as time passes after harvest, and post-harvest handling and storage practices can also reduce the levels of antioxidants. While some

vegetables are picked prematurely to allow for ripening during transportation, vine ripening is better for producing the best tasting, most nutrient-dense foods.

- **Increased regional economic health.** Buying locally grown foods keeps money within the community and produces a stronger local economy. This contributes to the health of all sectors of the local economy and increases the local quality of life.
- **Support for self-sufficient communities.** A community that produces its own food can better influence how it is grown. It is also less reliant on far-away food producers, which would be critical in the case of a natural disaster or national security crisis if major transportation routes were blocked.
- **Help for preserving biodiversity.** Farmers who sell locally are not limited to the few fruit and vegetable varieties that are bred for long-distance shipping, high yields, and shelf life. Often they raise and sell wonderful heirloom varieties that may be hard to find in supermarkets.
- **Preservation of the rural character of the land.** Supporting local farmers means maintaining local farmland, which is much better for the local climate than putting up malls and parking lots.
- **Avoidance of post-harvest contamination.** Foods sold in local markets without the need for extensive storage and transportation will likely contain minimal or no waxes and/or fungicides applied to protect the product after harvest.

One of the easiest ways to buy your food locally is to go to your local farmers' market. It is a great way to enjoy people-watching and find some local heirlooms, like tomatoes of all shapes and colors, some rich in lycopene, others in related nutritious carotenoids. Indeed, the fastest

growth segment of the produce industry is the local farmers' market, where people are coming in droves to buy locally grown foods and to reconnect with their communities and the earth.

Community Supported Agriculture (CSA) is a way for the food-buying public to create a relationship with a farm and to receive a weekly basket of produce. By making a financial commitment to a farm, you become a shareholder or subscriber. Many CSA farms offer produce subscriptions, where buyers receive a weekly or monthly basket of produce, flowers, fruits, eggs, milk, coffee, or any type of farm products.

Some CSA farms also require that members work a small number of hours on the farm during the growing season, which typically runs from late spring through early fall. The number of CSA farms in the United States was estimated at 50 in 1990 and has since grown to more than 1,000. This is a very promising trend; let's continue to support local food producers and halt global warming in its tracks!

Resources

- www.ams.usda.gov/farmersmarkets
- www.csacenter.org
- www.localharvest.org

STEP #7
Adjust Your Thermostat

How's this for simple: You barely have to lift a finger to adjust your thermostat! A mere two-degree adjustment to your home's thermostat setting (lower in winter, higher in summer) can prevent about 2,000 pounds of carbon dioxide from entering the atmosphere every year.

Heating and cooling systems use more energy than any other system in our homes, accounting for 42 percent of the average family's energy dollars. Heating (with gas or electric heaters) and cooling (with air conditioners or electric fans) requires the burning of fossil fuels such as coal and natural gas, resulting in higher carbon dioxide emissions.

Programmable thermostats also go a long way to saving energy—especially when you are sleeping or out of the house—and can save about $100 each year on your utility bill. For some great ideas on how to cool or warm your home without fossil fuels, see Step 34, Turn Off Your Air Conditioner.

Remember, simple actions make great impacts.

Resources

- www.aceee.org
- www.climatecrisis.net

STEP #8
Unplug Your Chargers

Did you know that 95 percent of the energy used by mobile phone chargers is wasted? Only 5 percent of the energy goes to actually charging the phone, while the rest is consumed by continuing to pull electricity out of the wall socket after the unit is fully charged (even in standby mode), according to Future Forests, an organization that offsets carbon emissions by planting trees.

That's more than 100,000 tons of carbon dioxide emissions in the U.S. and well over 50,000 tons in the UK that could be avoided if we all just unplugged our chargers once our phones were fully charged.

Think of the impact if we all did this! Ready? One, two, three, unplug! Could it be any simpler?

Michael Graham Richard at treehugger.com tells us, "If you have a cell phone, have you ever noticed that your charger stays warm even when you are not charging your phone with it? That's because it is still draining electricity."

In addition to needlessly increasing greenhouse gas emissions, leaving our chargers plugged into the wall all day wastes money and adds to the pollution created by burning fossil fuels.

This step isn't just for your cell phone. It also applies to your iPod, camera, rechargeable batteries, computers, video games—anything using a charger.

With an estimated 190 million cell phones in the U.S. each drawing a watt of power, if we all unplugged all of

these chargers after use, it would save up to 190 megawatts *per day*, says *The Green Guide*. "That's enough to power approximately 100,000 homes." If we did the same with all our other electronic devices, we could save enough to power a small U.S. city.

Yes, even many home electronics without chargers drain energy, when plugged into the electric socket and in the "Off" position. These appliances draw energy to stay in ready mode so they will have the same setting as when you turned them off. Surprisingly, these plugged-in, unused appliances make a tremendous impact. According to the U.S. Department of Energy, about 75 percent of electricity used for home electronics is consumed while they are off!

To make this step simpler, plug several appliances into a powerstrip, so you can easily turn them all off with the flick of a switch each night. But however you do it, pull the plug. (Go do it *now*!)

Resources

- www.energy.gov/applianceselectronics.htm
- www.greenguide.com
- www.treehugger.com

STEP #9
Buy an Organic Mattress

Here's something to think about the next time you buy a mattress: how well do you know what you are sleeping on? Many of us would not link our mattresses with global warming, but taking a closer look reveals that the manufacturing of mattresses and bedding is one of the major non-fuel uses of petroleum.

Most mattresses are made with large amounts of global warming–linked, synthetic petroleum-based chemicals like acrylonitrile, polyethylene, teraphthalic acid, ethylene glycol, polyester, nylon, and polyurethane (PU) foam.

Not only are these toxic petrochemicals bad for your health—they seep into your skin and off-gas into your lungs—but, like all petrochemicals, their production creates greenhouse gases.

"Unfortunately, the safety of these chemicals alone or in combination is not well understood," says Walter Bader, author of *Toxic Bedrooms: Your Guide to a Safe Night's Sleep*, "but what we do know suggests they could be causing significant damage to our health."

Even very low levels of polybrominated diphenyl ethers (PBDE), a flame retardant commonly used in mattresses and upholstered furniture, are now known to affect the health of the developing fetus. Another petrochemical used in mattresses, perfluorooctanoic acid (PFOA), is a suspect carcinogen.

We also know that as well as being toxic to the human body, these harmful chemicals are contributing significantly to the greenhouse gases in our environment. One study showed that these chemicals are doubling in concentration in the environment every two to five years, when measured in people and wildlife throughout North America.

However, consumer demand for healthier products has caused manufacturers to take note and offer green alternatives in mattresses and bedding. Eco-friendly mattress manufacturers are springing up in many places, selling mattresses made from natural materials like organic cotton and natural latex (from rubber trees), and containing little or no toxic petrochemicals.

Lifekind, for example, is the single largest purchaser of organic cotton mattresses in the United States and uses an exclusive non-chemical sterilization process to sanitize its raw materials. While using absolutely no brominated fire retardants, their mattresses still comply with federal and state mattress laws for non-flammability.

Mattress-In-A-Box by Modern Comfort is made from 75 percent recycled or recyclable materials and uses non-chemical agents such as green tea extract, bacteria-killing nanosilver, and bug-repelling cedar oil. Check out the resources below for other great choices.

When it comes to wood for your bed and mattress frame, the most verifiably green products are those that bear the Forest Stewardship Council (FSC) label. You can find examples at If Green (www.ifgreen.com), or check out Tamalpais's Eco-Styler bed kit which includes unfinished wood and hardware for twin- through king-size beds. A Natural Home also offers bed frames from locally sourced, non-clear-cut solid oak and uses tung oil (derived from nuts and petroleum-free) for their finish.

Futons offer another alternative to the traditional synthetic mattresses. Often made from cotton or wool, they require less energy to make and are biodegradable.

Buying sheets, comforters, and other bedding, made from natural materials is also a good idea. Choose organic cotton or wool rather than cotton-polyester blends (as polyester is derived from petroleum). They are often more comfortable too.

Indeed, sleeping on a healthy, green bed is an important decision with an oft-unrecognized real impact on our environment, our health, and our planetary future. Take a look in your bedroom(s) and see where you can begin to make changes today!

Resources

- www.anaturalhome.com
- www.bedzine.com
- www.greenfeet.com
- www.ifgreen.com
- www.lifekind.com
- www.savvyrest.com
- www.serenitypillows.com
- www.tamalpais.com
- www.theorganicmattressstore.com
- www.underthecanopy.com

STEP #10
Buy Recycled
Paper Products

Have you ever had the pleasure of visiting a rainforest? These gorgeous habitats, characterized by high rainfall, are home to two-thirds of the living animal and plant species on the earth and are the source of many of the earth's natural herbal medicines. Rainforests are also critical to our fight against global warming, as they absorb tremendous amounts of carbon dioxide. In fact, every 2.47 acres (one hectare) of rainforest absorb a ton of CO_2 per year! And ancient forests (as opposed to new growth) are by far the most effective at processing CO_2.

Tragically, forests are being harvested for paper and other products at an alarming rate. About half of mature tropical rainforests have been cleared, and if we continue harvesting trees at current rates, there will only be 10 percent remaining by 2030. If everyone in large cities could experience the beauty of the rainforests and witness the millions of rainforest trees being cut down to be turned into paper products, we would certainly take immediate steps toward stopping this process. The simplest and most effective action we can take right now is to purchase recycled paper products.

Every time you buy a pound of recycled paper, you eliminate about four pounds of carbon dioxide from ever being produced, as recycled paper takes less energy to produce.

Recycled paper products can be found in nearly every store that sells paper. Office supply giants Staples and

Office Depot sell their own brands of recycled paper containing 30 percent and 35 percent post-consumer recycled content, respectively. You can also buy their 100 percent post-consumer recycled content paper—even better.

Pre-consumer recycled content is made from the waste materials from the manufacturing process of another product. For example, an envelope manufacturer might recycle the clippings left over when envelopes are cut from paper. These clippings are now being used rather than thrown away.

Post-consumer recycled content is material with a past life such as a newspaper, magazine, office paper, packaging, paper cup, or paper plate. Using post-consumer paper waste closes the circle of recycling, reusing our resources and reducing our need to cut down more trees. Remember: more trees means less carbon dioxide! And of course, less CO_2 is synonymous with reduced global warming!

Supporting green-conscious companies like Staples and Office Depot, who purchase their paper products from suppliers committed to employing sustainable methods of harvesting, encourages other suppliers to follow suit in the green revolution. Other environmentally aware companies include the following:

- Bowater is one of the largest paper suppliers in the world and purchases more recycled tires and newspapers than almost any other company nationwide. Bowater has signed a covenant with the Southern U.S. forest protection group Dogwood Alliance to only purchase wood that was harvested from certified sustainable forests.
- Potlatch harvests wood from more than a million acres of forestland in Arkansas and Idaho that are certified according to the rigorous standards of the Forest Stewardship Council (FSC).

- Domtar is a forest products company striving to meet its goal for all of its suppliers to be certified to FSC or equivalent certification standards. The company obtained ISO14001 environmental certification (the internationally recognized standard for Environmental Management Systems) for its forestry management practices in more than 18 million acres of directly managed forestland.
- GreenerPrinter, based in Berkeley, California, offers reprints on 100 percent recycled New Leaf paper stock with soy-based inks. GreenerPrinter ships its print jobs Climate Cool™, as certified by the Climate Neutral Network. This means that the climate emissions associated with shipping by truck or airfreight are certified by an Environmental Review Panel to achieve a net-zero impact on the earth's climate. This company is also a member of the Green Patriot™ Green 100™.
- New Leaf Paper provides high quality business paper, including the first coated paper made from 100 percent post-consumer waste available in the U.S.
- International Paper is a charter member of the EPA's National Environmental Performance Track program. As one of the world's largest paper and forest products company, International Paper is committed to sustainable forestry in the forests they manage.

Recycled office paper comprises only a portion of the recycled products we can purchase. Buying recycled paper towels, facial tissue, and toilet paper also takes a huge chunk out of global warming greenhouse gases that would otherwise end up in our atmosphere. If everyone in the U.S. replaced their non-recycled paper products with the

recycled equivalent, the earth would achieve a savings of 666,369 tons of greenhouse gases!

There are many sources for recycled paper products today, including private label brands such as 365 at Whole Foods Market and Earth First at Safeway; popular growing eco-brands like Seventh Generation and Planet, Inc.; and websites like Treecycle.com, that even sell recycled gift boxes.

With so many options for buying recycled paper products today and our rainforests and planet at stake, we can't afford not to make the switch to recycled paper.

Resources

- www.bowater.com
- www.climateneutral.com
- www.domtar.com
- www.fsc.org
- www.greenerprinter.com
- www.internationalpaper.com
- www.newleafpaper.com
- www.officedepot.com
- www.planetinc.com
- www.potlatchcorp.com
- www.seventhgeneration.com
- www.staples.com
- www.treecycle.com

STEP #11
Buy Organic
Fair Trade Coffee

Who would have thought that buying a cup of organic coffee could help save the planet? Or to give this little thought more of a java-inspired jolt: How about drinking a cup of coffee and saving a climate-stabilizing rainforest?

When it comes to our coffee, we've been buying into the petrochemical processing linked with global warming and sponsoring heavy spraying of chemicals that sicken workers and their children who live where conventional coffee is grown. We've also been destroying our own climate-critical rainforests.

"For the last 35 years, the trend away from the traditional shade-grown coffee farms to sun farms has decimated forests," says supermarket guru Phil Lempert. "Of the 6 million acres of coffee farms today, some 3.6 million have been stripped of shade trees," he says. We have helped to eliminate bird species while increasing the presence of devastating insects and fungi that attack the coffee plants, thereby requiring tons of toxic pesticides to offset losses of up to 35 percent of the crop.

Buying organic coffee stops this trend and makes your cup of coffee not only an indulgence but an act of sheer environmental consciousness.

The organic fair trade label virtually ensures that the coffee is produced under safe and healthy working conditions exemplifying fair trade and emphasizing

sustainable development and a fair price for producers.

Choosing organic *shade-grown* coffee rather than sun-farmed coffee is also important.

"Growing organic coffee isn't only about not using chemical pesticides and fertilizers," says the Green Mountain Coffee Roasters (the nation's leader in sourcing fair trade coffee) website.

"It's really about being in tune with the environment, and working with the ecosystem, rather than *against it*. Organic farmers are reaching back to their traditions: replanting trees to grow coffee under natural shade canopies, enriching the soil with natural compost...and along the way they're reaping the benefits of a rich and diverse flora and fauna, and greatly improved water quality."

The Audubon Society says that coffee forests serve to cool the earth by the evaporation, transportation, and recycling of millions of gallons of water, favoring cloud formation and abundant rainfall. Interrupt this natural flow and you interrupt the life of the land and the trees and the weather patterns of the earth.

The nitrogen-fixing shade trees provide habitat for birds and butterflies that, in turn, provide natural insect control with their constant foraging, all without fungicides and pesticides.

"Shade-grown coffee plantations play a key role in the conservation of migratory birds that have found a sanctuary in their forest-like environment," says the Smithsonian Migratory Bird Center.

Here's what you can do:

Demand organic coffee. If your favorite coffee place doesn't have it, find one that does. Dunkin' Donuts has fair trade espresso. If enough of us do this, we will have fair trade on the daily menu for all cups of coffee (as well as when buying by the pound).

Although shade-grown coffee (which is almost always grown organically) makes up only around 1 percent of the U.S. market, if everybody changed now and bought a pound a month of fair trade coffee, you can imagine what a positive impact that would have on the rainforests. The easiest way to do this is to go online to www.greenmountaincoffee.com.

There are also other great companies to buy from. By the end of 2008, 50 percent of Caribou Coffee Company's coffees will be Rainforest Alliance certified! One simple thing to do is to participate in their Bird Friendly® coffee program created by the Smithsonian, which supports 32 farms in 7 countries—Bolivia, Colombia, El Salvador, Guatemala, Mexico, Peru, and Venezuela—that produce "Bird Friendly"-certified coffee beans to sell to roasters in the United States and Canada.

The more than 2,372 growers on these farms produce in excess of 7,777,308 pounds of coffee on more than 7,236 hectares of shaded farmland. Growing coffee naturally keeps our planet in balance, thus helping to control global warming.

Resources

- www.cariboucoffee.com
- www.greenmountaincoffee.com
- www.nationalzoo.si.edu/ConservationAndScience/ MigratoryBirds/Coffee/default.cfm
- www.sweetwaterorganiccoffee.com

STEP #12
Give Your
Car a Rest

We bet that poor petro-beast gas-guzzling dinosaur chariot you call your car would just love a little rest too.

Go on. Give your car a rest. Did you know that cars and trucks account for 25 percent of the United States' carbon dioxide emissions? More bicycle riding and other lifestyle changes are desperately needed to reduce the climate-altering carbon emissions that threaten our planet.

So how do you do it? How do you give your car a rest?

Start with your routine Friday night run to the video store. How about walking or bicycling there? Or eliminate the trip entirely by joining Netflix or Blockbuster By Mail. When you run errands by bike or receive your DVDs by mail, you become part of the solution to global warming. If we all gave our cars a rest even once a week, we would markedly reduce global warming gases, and save money as well.

Driving releases some six pounds of carbon dioxide per gallon of gas into the air. Walking or biking short distances add up to big savings in pollution (and big gains in weight loss)! Even driving five miles to the video store twice a week can add hundreds of extra pounds of pollution in a year's time.

Here are some simple yet powerful things we can do to cut our emissions, with or without our cars (including ideas from the smart folks at globalwarmingsolutions.com):

- **Carpool.** By sharing rides, you can help to cut carbon emissions and traffic congestion. Carpooling is a great idea for getting to work (see Step 25, Green Your Office), but it can also apply to running errands and going to recreational activities. If you organize a shared weekly trip to the grocery store with your neighbors, you will likely have more fun as well.
- **Use mass transit.** The key to mass transit is the word "mass." The more of us who use it, the more global warming pollution it prevents. A bus with just 7 passengers is more fuel-efficient than the average car. A full bus is 6 times more efficient, and a full train is a whopping 15 times more efficient. Public rail and transit systems are leading the way in switching to low-emission electric vehicles (see Step 21, Use Electric Transportation), and our next generation of diesel trains promises to be superbly energy efficient compared with today's engines.
- **Walk more often.** Besides the obvious benefits to our planet, walking is great for you, both physically and psychologically. And you will notice natural beauty and things of interest in your neighborhood that you miss when driving by. So why not do it more often?
- **Avoid a trip.** Consider if you need to run that single errand today or if you can combine two or more errands in one trip tomorrow. Also ask yourself if your errand is something that could be done online. (See Step 40, Do it Online.)
- **Ride a bike.** Similar to walking, the health benefits of safe bicycling are tremendous. If your neighborhood is full of inclines, consider an electric bike, like the Electra Karma. (See Step 21, Use Electric Transportation.)

- **Skateboard.** You can cruise surfer style to "Dogtown" in the spirit of the Z Boys on a sustainable wood skateboard. Koa Blunt makes wide-decked, blunt-nosed skateboards from sustainable Koa wood. A portion of their profits goes to the protection of the ancient Hawaiian Koa forests.
- **Slow down.** Did you know that cars burn 20 percent more fuel at 75 mph than they do at 55 mph? In addition, aggressive driving (rapid acceleration and breaking) can lower gas mileage by 33 percent at highway speeds and use an extra 125 gallons of gas each year.
- **Lighten up.** An extra 100 pounds in your trunk can reduce your mpg by as much as 2 percent. Leave heavy items at home in the garage unless you need them for your outing.
- **Avoid rush hour.** As you idle in traffic, your mpg drops to zero. If all drivers found a way to eliminate just 2 minutes of idling time each week, we would save 400 million gallons of gas every year, according to thegreencurve.com

To defeat global warming, we will need to reduce our carbon trails. By implementing this step once a week or more, we will make a real impact on greenhouse gas production and help to halt global warming.

Resources

- www.globalwarmingsolutions.com
- www.thegreencurve.com

STEP #13
Wear Organic Clothing

We all know that oil refining is one of the most prevalent causes of global warming. Most of us don't realize, however, that many of the fibers in the clothing we wear (for example polyester and Dacron) are made from petroleum.

The famed polyester suit coat is actually made from polyethylene terephthalate (PET), and much of our basic clothing contains at least some nylon—another synthetic clothing material—especially socks and underwear. All of these petrochemicals, so widely used in clothing, contribute to global warming gases and affect our health.

So you say you'll wear cotton? That's a noble thought, but switching to cotton alone isn't enough. Cotton, the most used clothing fabric in the world, represents a $300-billion global market. Cotton crops use more petroleum-derived fertilizers and pesticides than any other single crop, including about one quarter of all agricultural insecticides applied globally each year.

In addition, according to the EPA, 7 of the top 15 petrochemical-based pesticides used on U.S. cotton crops are potential or known human carcinogens. All of this spells bad news for our health, the health of people who work with these crops, and the health of our planet in terms of global greenhouse gas emissions.

We can certainly make a difference by simply buying organic cotton socks, T-shirts, and pajamas. You can find

organic clothing staples in comfortable organic cotton or hemp at green retailers like Whole Foods Market, online at www.ecoshoppe.com, or from many of the websites listed under resources, below.

Some of the biggest names in clothing today, including Levi Strauss, Victoria's Secret, Esprit, Patagonia, and Timberland, also offer organic cotton products, as do mass retail outlets such as Wal-Mart and Target. And while more new designers are using organic cotton (see resources for examples), some cutting-edge fashion designers like Linda Loudermilk are using alternative renewable fabrics, made from materials such as bamboo and soya.

Indeed, many new eco-friendly textiles are popping up on the clothing racks. Some natural, renewable clothing materials include the following:

- **Soy cloth** is a new fiber made from the leftover dregs of soybean oil and tofu production. Durable and strong, but also soft and lustrous, soy fiber is stronger than wool, almost as warm, and requires no dry cleaning.
- **Soy cashmere** is the world's first cloth made from soybeans. The eco-friendly fiber is made from the unused protein of soybean oil, tofu, and soymilk production. Called "cashmere" because of its incredible softness, the fabric is blended with organic cotton and spandex.
- **Bamboo**, the fastest growing plant in the world, makes soft, breathable, antimicrobial clothing that keeps moisture away from your body. This sustainable, natural resource thrives naturally without the use of any pesticides or fertilizers.
- **Hemp** fabric feels similar to linen. Durable and insulating, it's comfortable in all temperatures. The fabric is also available in wool and silk blends.

- **Tencel** is the trade name for a manmade, natural fabric also known as Lyocell that is cool and breathable like rayon. It's made from the cellulose of farm-raised trees, grown in soil deemed unsuitable for food.
- **Recycled plastic bottles** are being processed into fiber to make yarns and textiles, made popular by the environmentally aware clothing company Patagonia.

Several online retailers featuring hip clothing made from these and other organic materials include upstarts like ShopEnvi, Bamboo Styles, Grassroots Natural Goods, Kait, and Gaiam.

Choosing clothing made from organically grown cotton and other organic, natural, and sustainable fibers may be one of the best and easiest things you can do as a Green Patriot to help save the Earth. The wide range of great new green styles and fashions emerging is truly inspiring to all eco-fashionistas. By supporting green apparel manufacturers and avoiding purchases of petroleum-derived fabrics, you are helping to ensure a healthier future with reduced dependency upon fossil fuels.

Resources

- www.armoursansanguish.com
- www.bamboostyles.com
- www.bluecanoe.com
- www.ecodragon.com
- www.ecoganik.com
- www.ecoshoppe.com
- www.edun.ie
- www.enamore.com
- www.esperanzathreads.com
- www.gaiam.com

- www.globalexchange.org
- www.grassrootsnaturalgoods.com
- www.gypsyrose.com
- www.lindaloudermilk.com
- www.maggiesorganics.com
- www.naturevsfuture.com
- www.oftheearth.com
- www.shopenvi.com
- www.stewartbrown.com
- www.turkandtaylor.com
- www.twostardog.com
- www.underthecanopy.com
- www.xylemclothing.com

STEP #14
Use Petrochemical-Free Household Products

Sadly, most modern household cleaning products rely on petrochemicals. Floor cleaners and polishes emit aromatic vapors from petroleum distillates. And chemicals like butyl cellosolve, the main ingredient in Windex, are directly lined to global warming petrochemicals.

Petrochemicals are chemicals derived from fossil fuels, most often from petroleum, and sometimes from coal or natural gas. If all of us make simple choices like choosing products without petrochemicals, then our shopping choices can help to reduce our impact on global warming.

In addition to their effects on the environment, some household cleaning products are downright dangerous to your health. Paint strippers contain the petrochemical methylene chloride, which is toxic to the cardiovascular system and has been known to cause fatal heart attacks. Dishwashing soap detergents are made with prime petroleum distillates like ethylene oxide, which is known to cause cancer.

The greenest carbon neutral products sold today are made by companies such as Aubrey Organics, Begley's Best, Dr. Bronner's, Earth Friendly, Ecover, and Seventh Generation. You'll find these brands at natural product supermarkets like Whole Foods Market and Wild Oats, as well as at thousands of health food retailers.

You can make your own effective cleaning products, too. One of the safest cleaning and disinfectant formulas is

casily made by mixing 2 teaspoons of borax, 4 tablespoons of distilled white vinegar, and 3 to 4 cups of hot water. Pour the mixture into a refillable spray bottle. For stronger cleaning power, add ¼ teaspoon of liquid soap.

A good homemade formula for removing bathtub and shower mildew is to make a paste from baking soda and water. Pour ½ cup of baking soda into a large bowl, add water and stir until the mixture reaches the consistency of a paste. Use a hard-bristled brush for general mildew removal and a hard-bristled toothbrush for removing mildew in between tiles.

A stronger multi-purpose household cleaner can be made with liquid soap and trisodium phosphate (TSP). Once again, you will need a refillable spray bottle. Mix 1 teaspoon of liquid soap, 1 teaspoon of TSP, 1 teaspoon of borax, 1 teaspoon of distilled white vinegar, and 1 quart of warm water. This formula is effective against both grease and mildew. Be sure to use TSP only when it is diluted and wear latex gloves when mixing the formula.

Resources

- www.begleysbest.com
- www.ecos.com
- www.ecover.com
- www.lifekind.com
- www.seventhgeneration.com
- www.sunandearth.com
- www.traderjoes.com

STEP #15
Use
Petrochemical-Free
Cosmetics

Most people don't realize that their favorite cosmetic and personal care products are made with petrochemicals (chemicals derived from petroleum). The cosmetic industry's use of these chemicals increases global carbon emissions and speeds up climate change. You can make a difference in our climate and in your own personal health simply by purchasing petroleum-free cosmetics.

As they are not regulated by the Food and Drug Administration or other governmental agencies, most cosmetics contain many toxic ingredients. Some commonly used petrochemicals cause cancer and can harm a fetus. So buying the usual drug store formulas is akin to ignorantly inviting destruction to the planet, your own body, and your children.

Take shampoos for example: Mainstream cosmetic companies use a global warming–linked petrochemical called ethylene oxide to manufacture their products. They combine ethylene with sodium lauryl sulfate to form a slightly softer-feeling sudsing agent called sodium laureth sulfate. Unfortunately, ethylene oxide causes cancer and breaks down into 1,4-dioxane (diethylene oxide), which is a probable human carcinogen as well. This poses a real risk to children who frequently are bathed or shampooed in these contaminated formulas, not to mention what its use does to exacerbate the release of global warming–linked carbon emissions.

In his book *Safe Trip to Eden*, Green Patriot environmental movement founder David Steinman said he tested for and found these harmful chemicals in many popular products, although none were disclosed on the ingredient labels.

Many cosmetics also contain phthalates, petroleum-based fixatives used in fragrance which are suspected of having feminizing and endocrine-disruptive effects on the reproductive organs of the male fetus.

Parabens (petrochemical preservatives) have estrogenic effects as well. Very often products contain all three of these chemicals—1,4-dioxane, phthalates, and parabens—in the very same formula.

Green Patriot environmentalists can easily send a strong message to the cosmetic industry by buying products made without these harmful ingredients. A few herbal extracts won't make up for the fact that a company's shampoo is a contributor to global warming processes and contains a cancer-causing chemical.

So here's what you do: Stop buying the chemical stuff, and go for the high-quality eco-friendly cosmetic and personal care products.

The leader is Aubrey Organics, a member of the Green Patriot Green 100. Aubrey has completely sworn off petrochemicals. Other good brands include Avalon Organics, Aveda, Dr. Bronner, Dr. Hauschka, Lily, Logona, MyChelle, and Weleda. These all have great lines that are virtually or completely petrochemical-free.

Once you become aware of natural and organic hair and skin care, then you will have a full appreciation for the wonderful healing therapies of pure nature. These cosmetics are not like the chemical drug store and department store brands; they are good for you and good for the environment, and they don't contribute to global warming.

Resources

- www.aubreyorganics.com
- www.avalonorganics.com
- www.aveda.com
- www.drbronner.com
- www.drhauschka.com
- www.lilyorganics.com
- www.logona.com
- www.mychelleusa.com
- www.weleda.com

STEP #16
Compost Your
Food Waste

Did you know that tossing your leftovers into the trash feeds methane gas into the atmosphere? Methane is an even more potent greenhouse gas than carbon dioxide and much of it is produced by food waste in landfills.

While a few companies like S.C. Johnson are harnessing landfill gases to use as an alternative energy source, they are still the exception. The majority of our food waste ends up decaying in landfills and oozing harmful methane fumes that contribute to global warming.

According to the EPA, 12 percent of the total discarded materials in the United States (in 2003) was food waste, with 54 percent comprising fruits, vegetables, grains, and milk. The United States Department of Agriculture tells us that Americans throw away an average of 163 pounds of food per person every year. In 2002, Americans threw away more than 190,000 tons of food and spent $50 million paying for the landfills to store it.

Fortunately, we can put much of this trash to good use by composting it. Most of your food scraps, including vegetables, fruits, egg shells, and coffee grounds can be composted.

Composting basically entails combining food scraps with garden clippings and letting the mixture decay into natural fertilizer for the soil. This natural process serves a dual purpose of producing less methane and keeping more carbon dioxide in the soil.

"If you're interested in doing your bit for global warming, composting is one of the best things you can do," says compost expert and author Ken Thompson. Besides making one of nature's finest mulches and soil amendments, compost helps trap carbon in the soil, keeping it out of the atmosphere. Thompson explains, "Soil is the safest place for waste organic matter"…and "is the largest [storehouse] of carbon; there is more in soil than in all the trees and plants."

The benefits of adding compost to your soil are many and include added fertility, healthy root development, better aeration, and increased water-holding capacity. It will likely even save you money otherwise spent on fertilizers and will improve your soil's condition, feeding it naturally with the nitrogen, potassium, and phosphorous produced in the composting process. Another benefit is that you will use fewer plastic garbage bags (which are typically made from petroleum).

Here are a few basic rules for creating your garden compost pile:

- Compost piles need equal amounts of green and brown materials, as well as water. Green materials include grass clippings, fruit and vegetable peels and scraps, egg shells, and coffee grounds. Brown materials are dead leaves, twigs, and branches.
- Be sure not to add dairy products or fats. These tend to cause odor and attract pests.
- Limit the size of your compost pile to 3 feet by 3 feet.
- Aerate your compost pile by turning it when adding new materials, as oxygen is needed to break down the wastes into organic matter.
- Keep the compost pile moist, but not too wet.
- Consider using worms to speed the decaying process.

If you don't have a yard, you can compost on a patio or balcony with small, barrel-type composters or tumblers available online and at most garden centers. They are reasonably priced and have the advantage of producing small batches of composted material quickly.

For those who are restricted to indoor composting, you have a few options:

Vermicomposting—indoor composting with earthworms, using a small bin. The small bin takes up little space and the worms help to speed the composting process and keep odors to a minimum.

Using an indoor anaerobic kitchen composter. For around $75, you can purchase a special anaerobic composting "pail" and compost starter. The process, if followed correctly, is odor-free and fast.

Using an automatic indoor composter. For those willing to shell out $300-$500, you can have an indoor composting unit do the job for you in a short time. Nature Mill (www.naturemill.com) manufactures energy-efficient units made from recycled material.

You can find a great selection of composting products at www.composters.com. Be sure to check with your city's department of sanitation for composting information. The New York City Composting Project also has helpful instructions for apartment composting online at www.nyccompost.org.

Resources

- www.composters.com
- www.compostguide.com
- www.epa.gov/compost
- www.naturemill.com
- www.nyccompost.org

STEP #17
Be a Carbon Neutral Gardener

How does your garden grow? While we usually think of gardening as a healthy and natural activity, if you use chemical pesticides and fertilizers as part of your gardening protocol, you may actually be doing as much harm as good. In America, more than 67 million of us spend over $33 billion annually in garden-related expenses. Unfortunately, too many of those dollars are spent on petrochemically derived products that are harmful to humans, animals, and our planet.

Leukemia and childhood brain cancer have been linked with pesticide, insecticide, and weed killer products use, especially those which include diazinon and carbaryl. Manufacturing these chemicals also adds to the greenhouse gases in our environment.

The good news is that tending our gardens without these harmful petrochemicals is easy. A Google search for "carbon neutral gardening" will reveal many companies that are dedicated to natural gardening practices and products. Clean Air Gardening is one such company that offers online resources and products for green gardening and matches customer donations up to $10 to Trees for the Future during online purchases.

Your carbon neutral gardening strategy should include these elements:

Use organic fertilizers. Organic fertilizers include natural materials that have been used for generations to

grow healthy plants and vegetables that are good for the body, the soil, the earth, and the air. Here are a few good options:

- **Bat Guano**, the "ultimate 100 percent natural fertilizer," contains humus and builds and fertilizes the soil.
- **Fish Meal Organic Fertilizer** is a complete plant food, containing trace elements.
- **Kelp Meal Fertilizer** supplies plant growth hormones, essential minerals, and organic material.
- **Organic Weed and Feed**, made from pelletized corn gluten meal, a byproduct of corn syrup manufacturing, works as a natural herbicide and preemergent weed control and fertilizes the soil.
- **Compost** is a natural fertilizer you can make yourself. You can even add your own lawn and garden trimmings to the compost pile! (See Step 16, Compost Your Food Waste.)

Control pests naturally. With all of the options nature has given us to rid our gardens of pests, relying on harmful chemical pesticides to do the job is unnecessary and irresponsible. Here are some ideas:

- **Companion planting** involves using certain plants and herbs in combinations to repel pests and keep plants strong. Peppermint repels white cabbage moths, aphids, and flea beetles, and sunflowers help control aphids. Good soil and the right amount of sunlight will make plants more resistant to pests as well.
- **Natural pesticides** include plant extracts, fatty-acid soaps, diatomaceous earth, sticky traps, beneficial insects, and garlic. Some products repel pests rather than kill them, and all of the natural products are easier on the environment than chemical pesticides.

Use a push mower instead of a gas-powered one! Yes this is important. Despite their obvious convenience, gas-

powered lawn mowers are among the worst offenders in the battle to reduce carbon emissions. In fact, just one hour of mowing generates the equivalent emissions to driving 140 miles in your car, according to pscleanair.org. Push or reel mowers are also quieter and provide exercise, and according to stopglobalwarming.org, using them will save 80 pounds of carbon dioxide per year. For those of you with enormous lawns, watch for the development of hybrid and alternative mowers in the near future.

Reduce your lawn. Minimizing the space you devote to grass, which does not grow naturally in many areas, can significantly cut energy costs by reducing the temptation to use a gas-powered mower. Consider lawn alternatives including low maintenance groundcovers such as dichondra that require little or no mowing.

Plant lots of trees. If each of America's gardening households planted just one new tree, those trees would absorb around 2.25 million tons of carbon dioxide per year. (See Step 44, Plant a Tree.)

Plant native. As a plant's native environment naturally offers the conditions it needs to thrive, planting your garden with native plants requires less upkeep and is healthier for the environment than non-native gardens.

Resources

- www.ams.usda.gov/nop/indexIE.htm
- www.cleanairgardening.com/carbonneutral.html
- www.naturalawn.com
- www.nwf.org/gardenersguide/Gardeners_Guide.pdf
- www.plantnative.org
- www.pscleanair.org
- www.stopglobalwarming.org

STEP #18
Use Less Hot Water

Taking an occasional cold shower can actually help to reduce your CO_2 emissions! If you use less hot water, especially while washing your body and clothes, you can prevent more than half a ton of CO_2 from our atmosphere annually. And using less hot water also means more money in your pocket.

Here are some helpful tips:

1. **Adjust your water heater setting.** Turn your water heater down to 120° F—it will still be hot enough and you will see your hot water costs drop by up to 50 percent. You will eliminate scalding water accidents as well.

2. **Switch to a tankless water heater.** Rather than keeping your full water tank hot at all times, a tankless water heater will heat water as you need it, resulting in $390 annual savings and a hefty 300-pound CO_2 reduction.

3. **Do more of your laundry with cold water.** You can effectively wash most clothing without hot water, while preventing shrinkage as well. Using mainly cold water for your laundry can save about 500 pounds of carbon dioxide a year.

4. **Do laundry using a front load machine.** For the times when you need to wash in hot water, front load machines generally use much less water than the top load kind.

5. **Use a low flow showerhead.** Showers account for two-thirds of water heating costs. Low flow showerheads reduce the amount of water used for showers and can save you $150 per year, while preventing the release of 350 pounds of carbon dioxide. Even better, taking shorter showers will eliminate an additional 350 pounds of carbon dioxide and leave you with an extra $99 per year, according to stopglobalwarming.org.

6. **Get two-knob savvy.** If you have separate hot and cold knobs in your shower, when the water is too hot, get in the habit of turning down the hot knob instead of turning up the cold one.

By taking this simple step, you will help to reduce global greenhouse gases and enjoy lower heating costs as well.

Resources

- www.eartheasy.com
- www.stopglobalwarming.org

STEP #19
Drink Organic Wine

Drink red wine and live longer. Drink organic wine and help save the earth too! Many people know that red wine in moderation can be good for your heart and your health—a true anti-aging elixir—and when you drink organic wine, what's good for your arteries and cells is also good for the environment.

Red wine's health-enhancing ingredient, called resveratrol, offsets the negative effects of a high-calorie diet and has been shown to extend the lifespan in laboratory studies, as reported by researchers at the Harvard Medical School and the National Institute on Aging.

These findings may explain why French people suffer considerably less heart disease than Americans, despite consuming similar high-fat diets. If drinking red wine means living longer, we say, "à votre santé!" (Of course, check with your doctor before making any changes in your alcohol intake.) And when enjoying the vineyard's prescription for health, keep the planet's health in mind by purchasing organic wine.

Not only do organic wines taste great, they take us one step closer to environmental health by eliminating petrochemical pesticides, a family of chemicals that account for almost 5 percent of all uses of oil.

Fetzer is a big name in organic wines and stopping global warming. They began working organic crops in the 1980s, and today, they stake claim as "the largest grower of

certified organically grown grapes on the North Coast [of California] and one of the largest in the world." What's more, they show their dedication to the environment by powering their administrative building with 100 percent Green Power, obtaining 75 percent of the electrical needs from solar energy. Fetzer also takes pride in running a climate-neutral company.

Another well-respected organic winery, Frey Vineyards, is the United States' oldest (since 1980) and largest purely organic winemaker. Located in Mendocino County's Redwood Valley in California, this family owned and operated vineyard also produces Biodynamic® wines.

You can find an abundance of organic wines on the popular wine website www.theorganicwinecompany.com, or call them at 1-888-ECOWINE (326-9463).

Wherever you find your organic wine, remember moderation is the key. Drinking a glass of organic wine is a fun, simple way to help in the fight against global warming. Cheers!

Resources

- www.diamondorganics.com
- www.fetzer.com
- www.freywine.com
- www.theorganicwinecompany.com

STEP #20
Tread on Retreads (Recycled Tires)

If you traded in your old gas-guzzling vehicle for a new hybrid you're probably feeling pretty good about all the emissions you are no longer contributing to global warming. What about your tires, though? Do you know how much carbon dioxide is created in the production of a typical new tire? Did you know that you could help decrease the use of natural resources that strain our environment by purchasing retreads instead of new tires?

Retreaded tires are recycled tires. They are not the same as used tires. Unlike used tires that are unsafe because they don't have any tread, retreads have been refurbished to function like new tires, and they meet all the required safety standards.

Commercial transportation from airlines to trucking companies, and even school and city buses, routinely use retreaded tires. For these major outfits, it's not so much a matter of environmental concern as it is a matter of cutting costs.

That's right: Not only do retreaded tires use significantly less oil in production, they are also a lot less costly for consumers. In fact, because many tires, especially ones that were expensive when new, can be retreaded more than once, there is the potential for even greater savings. Speaking of savings, did we mention that retreads cut down on oil usage as well? A medium-sized truck tire takes 22 gallons of oil to produce, while a retread takes only 7 to

8 gallons. As oil is a big contributor to global warming, treading on retreads rather than new tires is one way you can significantly help conserve this valuable resource.

Retreading tires also keeps rubber out of our landfills and reduces the amount of new rubber needed to make tires. When a tire has worn out its retread-ability, it can be recycled into other materials. Although retreaded tires have been used commercially for many years, they are just recently becoming more available for public use. By asking for retreaded tires, you can help make them a more popular and readily available option for other consumers. You can find a worldwide listing of retread providers at www.retread.org/Guide. The site, provided by the Tire Retread Information Bureau, also has detailed information about how retreads are made and will most likely answer any other questions you may have about retreads.

Resources

- www.environmental-expert.com
- www.epa.gov
- www.retread.org/Guide

STEP #21
Use Electric
Transportation

Electricity has transformed our society and economy, and it will play a key role in the critical transformation before us—whether to an environmental point of no return or to an era of true sustainability. Although the lion's share of electricity used today is still generated by coal-fired power plants, we can still significantly shrink our overall carbon footprint by shifting from gas to electric-powered transport.

Research from Plug-In America shows that even when pure electric vehicles are powered exclusively by coal, they still reduce carbon dioxide emissions by up to 60 percent when compared to internal combustion gasoline-powered vehicles. And when you consider the emergence of green energy sources for electricity, the future looks even brighter.

At the beginning of the 20th century, 40 percent of American cars were powered by steam, 38 percent by electricity, and 22 percent by gasoline. Prior to the dominance of the internal combustion engine, automakers like Henry Ford experimented with different power sources to find the most efficient means for personal automated travel. Thanks in part to the tremendous success of the automobile, today we are in a critical era of re-invention, this time keeping carbon emissions and environmental responsibility in mind.

Gas-electric hybrid cars are more available and affordable today than ever before, thanks to consumer demand. While Toyota and Honda lead the way, other car

companies such as Ford, Mercury, Nissan, and Saturn currently offer hybrid models, and many other automakers are scheduling hybrids for release over the next several years. (See www.hybridcars.com for the complete list.) Netting up to 50 mpg and sometimes qualifying for federal tax credits (as high as $4,000), hybrids are worth exploring. Look at The American Council for an Energy Efficient Economy's Green Book Online for ratings on these and all cars from a green perspective (www.greenercars.org).

While hybrids significantly reduce the need for gas, they do not deliver the benefits of pure "plug-ins" or 100 percent electric vehicles. Electric vehicles, also known as "EVs," were relatively plentiful in California in the 1990s due to a state requirement that automakers create a percentage of zero-emission vehicles. Although these cars were quite popular with consumers, they virtually vanished when the state rescinded the requirement, as chronicled in the documentary, *Who Killed the Electric Car?*

Today, thanks to public demand, automakers are developing zero-emission electric plug-in vehicles once again, as well as plug-in gas-electric hybrids that receive as much as 100 mpg. Two interesting cars on the horizon are the Tessla Roadster sports car with a target price near $100,000, which reportedly will travel 245 miles on a single charge of its lithium ion battery, and the more affordable Chevy Volt, which will travel up to 40 miles on battery power alone and can be configured to run on electricity, gasoline, E85, or biodiesel.

It's important to note that the cost of electricity to power up EVs is considerably lower than the price to fill them with gas. For example, Plug In America compared driving a 2002 Toyota RAV4 100 miles on gasoline for $10 (at $2.50 per gallon) and on electricity for only $3.

In addition to driving an electric car, there are several other ways to switch to electric transportation and lighten your carbon dioxide load. Plug-in electric bicycles combine the efficiency and exercise of pedaling with an electric boost when that next hill is a little too steep or long. Quite popular in Europe, they are now available in the U.S., as are electric pedicabs, scooters, and other personal conveyances. (See www.electric-bikes.com for a list of manufacturers and retailers.)

Whenever possible, use electric mass transit—once the mainstay in American cities in the form of trolleys, streetcars, and "trackless trolleys" (buses on streets connected to overhead wires). Today, cities are reviving these forms of electric transportation and adding electric buses to the green mix. Cities such as Santa Barbara and Chattanooga, Tennessee rely heavily on electric buses, while San Francisco runs vintage streetcars, cable cars, and zero-emissions "trackless trolleys" powered by hydroelectricity. Then there are electric subways, metros, light rail systems (for example, Minneapolis's "Hiawatha Line"), and monorails plying cities in the U.S. and around the world.

With the growth of alternative fuels (see Step 42), the increase in hybrid offerings, the re-emergence of electric vehicles, and the development of hydrogen and fuel cell technologies, our vehicles are auspiciously heading down a greener road (or track)! For today, electricity—whether from fossil fuels or green energy—is a carbon-lesser option than gas for powering your transportation needs.

Resources

- www.chevrolet.com/electriccar
- www.electric-bikes.com
- www.epa.gov/emissweb

- www.evworld.com
- www.greenercars.org
- www.hybridcars.com
- www.pluginamerica.com
- www.tesslamotors.com

STEP #22
Adopt a Panda

Birds, bees, fish, trees, and more than a million animal species from the polar bears to the kangaroos are predicted to go extinct by 2050. Global warming-induced climate change is largely responsible for this worldwide tragedy.

According to an article posted on *Scientific American's* website, "global warming may surpass other by-products of human activity, such as deforestation, in driving species into extinction."

The rising temperatures caused by the buildup of greenhouse gases produced by burning fossil fuels are making it impossible for animals to live as nature intended. Melting ice in the Arctic regions means walruses and polar bears are drowning and krill are dying off, which in turn affects the food source of the blue whales. A break in one piece of nature's interconnected web affects the whole network in one way or another.

Reducing GHG emissions is the number one step to take to exit this road to extinction on which we're currently driving, and preserving animals' habitats is another way we can help save the animals.

Joining the World Wildlife Fund's (WWF) wild animal adoption program is an innovative way to take real and concrete action toward preserving large areas of climate-stabilizing forests and jungles.

The WWF offers a choice of 40 different symbolic animal adoptions, which include a formal certificate, full-

color photo, and species fact sheet. Adopting an animal as a gift for children and adults is a great way to help protect their future and raise awareness about their current dire state.

The most endangered animal species are those living in areas hard to migrate from, including the tropical Andes, California, southwest Australia, and South Africa. By preserving precious animal sanctuaries in these regions, we are taking steps to keep these animals on the earth.

Our collective actions can ensure the future survival of these animals. The list of endangered animals is long and varied. It includes the following: chimpanzees, orangutans, seahorses, sharks, sea turtles, pandas, kangaroos, cheetahs, bears, walruses, whales, rhinos, elephants, koalas, polar bears, lions, leopards, wild horses, zebras, and tigers, to name just a few.

Conservation groups and the Chinese government are implementing plans to maintain the giant pandas' habitat. So far, more than 40 panda reserves have been established to help counter the loss of habitat resulting from massive population growth and deforestation.

Additionally, a new forest protection program launched by the government in 1998 includes a widespread ban on logging in virtually all panda habitats. A related measure calls for reforesting former farmland on steep slopes. These are good climate-positive changes.

In Africa, a census of mountain gorillas in the Virunga Montane forests, led by the WWF-funded International Gorilla Conservation Program (IGCP), has recorded an impressive 17 percent increase in the population of this highly endangered great ape.

Another unique, green adoption gift to consider purchasing is an acre of rainforest in someone's name. Organizations like World Land Trust, The Nature Conservancy, and The Rainforest Conservation Fund allow

you to purchase an acre of rainforest in your name or to give as a gift for as little as $100 per acre.

Rainforests fight global warming by absorbing substantial amounts of carbon dioxide. Purchasing rainforest acres through these organizations allows them to buy and protect the land, and the species that depend on it, indefinitely as reserves owned and managed by conservation groups.

Becoming educated and spreading the word to friends and family about how to help stop global warming and preserve animal habitats may help ensure the survival of endangered species for generations to come.

Resources

- www.ecologyfund.com
- www.endangeredspecie.com/Ways_To_Help.htm
- www.environment.gov.au/biodiversity/ threatened/publications/20-tips.html
- www.fws.gov/endangered/wildlife.html
- www.igcp.org
- www.nature.org
- www.rainforestconservation.org
- www.sciam.com
- www.therainforestsite.com
- www.worldlandtrust.org
- www.worldwildlife.org

STEP #23
Plant a
Rooftop Garden

As whimsical as it may seem, a rooftop garden is a surprisingly powerful weapon against global warming. Green roofs, also known as living roofs or eco-roofs, are the wave of the future in sustainable building design. They have a myriad of benefits including reducing CO_2 gases, cooling structures and their surroundings, providing insulation, and slowing storm-water runoff. Their resulting energy savings also means less fossil fuel use and less American reliance on foreign oil. If a rooftop garden can help save the world, let's get planting!

Simple and elaborate green roofs are sprouting all over today, from Vancouver, Canada, where condo dwellers share rooftop community garden plots, to Chicago, Portland, Seattle, and Maryland where businesses and homeowners take advantage of government tax incentives and assistance programs for planting living roofs. The California Academy of Science building in Golden Gate Park, San Francisco, features an immense green roof planted on a sloped surface, which is designed to harness the wind's energy to help control the building's interior temperature. BP America has included a green roof on top of its pilot green gas station project called "Helios House" in Los Angeles.

In an effort to help mitigate global warming, here are the top reasons to install a rooftop garden:
- Eco-roofs help moderate city temperatures which in turn, helps lessen fossil fuel energy use. Humidity

caused by the evapotranspiration (evaporation of soil moisture caused by heat), which occurs on green roofs, cools the surrounding air and lowers the temperature. The website www.gardens.com reports, "Increasing green space in Los Angeles by 5 percent could lower summer temperatures by 4 degrees." Additionally, "those lower temperatures would decrease smog by 10 percent and save $175 million in energy costs."

- Green roofs insulate buildings, keeping them cooler in summer and warmer in winter, thereby reducing carbon emissions from the fossil fuels used in cooling and heating. (And less energy used for heating and cooling saves you money!) Environment Canada found that a typical one-story building with a grass roof with 3.9 inches of growth resulted in a 25 percent reduction in summer cooling requirements. Field experiments in Ottawa, Canada, found that a green roof with 6 inches of growth reduced heat gains by 95 percent and heat losses by 26 percent, as reported by greenroofs.org.

- As is true for all plants, green roofs absorb large amounts of CO_2 through photosynthesis. In cities where there isn't a lot of room for planting, this is especially important. And the more plants we have to help offset the deficit of CO_2 absorption created by deforestation, the better. In addition to processing CO_2 into oxygen, these green patches also purify the air of pollution that passes through them—a significant added benefit. According to greenroofs.org, "one square meter of grass roof can remove 0.2 kg of airborne particulate from the air every year."

And if fighting global warming isn't reason enough to install a green roof, consider these added benefits:

- Providing an island of green in the ocean of city concrete, green roofs serve as a cool sanctuary for living creatures, including birds, bees, and butterflies. Green roofs also can serve as wildlife corridors for migrating species as they pass through or over urban areas.

- In addition to absorbing and reducing glare, eco-roofs are aesthetically pleasing, providing a calming, beautiful sanctuary for you and others to visit or gaze upon.

- Rooftop vegetable gardens can save you money. The Fairmont Waterfront Hotel in Vancouver used its green roof to grow herbs, flowers, and vegetables and saved its kitchen an estimated $30,000 a year in food costs.

- Green roofs naturally absorb water—typically 50-60 percent of the annual runoff volume—thereby helping to divert excess storm water from flowing untreated into rivers and lakes. As the sod can retain 90-100 percent of the first hour of heavy rainfall that can overwhelm storm-water management systems, this can also assist storm-water management and help in flood control.

- Green roofs trap and filter particles and pollutants from entering storm water, which also helps protect the marine environment.

- Rooftop gardens provide sound insulation from traffic and airplanes.

- Eco-roofs last considerably longer than typical roofs. The average green roof will last for 40 years, as opposed to standard roofing materials like cedar shake that has a 17-year expectancy, according to pomegranate.com.

But before you head up to your roof with a plant in one hand and a bag of topsoil in the other, know that planting a

green roof requires careful planning. Local climate factors like wind, sunlight, shade, average temperatures, and rainfall need to be taken into consideration. To protect your building in the long run, you will need to plan the irrigation, drainage, and plant anchoring intelligently. You can get excellent expert advice and see photos in the *Green Roof Manual* from Pomegranate Center in Issaquah, Washington. The organization Green Roofs for Healthy Cities offers classes around the country for professionally installing green roofs. Visit their website for more information.

Europe is leading the way with over 100 million square feet of green roofs. Let's follow suit! In addition to taking us a significant step closer to carbon neutrality, the growth of rooftop gardening will make America a much greener and more beautiful place to live. You can find out how to get started by visiting the websites below.

Resources

- www.greenroofs.com
- www.greenroofplants.com
- www.pomegranate.org

STEP #24
Use Green
Building Materials

Our early ancestors built their dwellings from natural materials they found in their environment. Wood, bamboo, mud, and palm fronds provided what they needed to construct their earth-friendly shelters, which they built without polluting the environment or creating harmful greenhouse gases.

Today, however, construction and maintenance of buildings accounts for 38 percent of carbon dioxide emissions, 68 percent of total electricity consumption, and 39 percent of total energy use in the United States, according to the EPA.

Fortunately, there are myriad ways that we can reduce the carbon footprint of our homes and other structures. The first step of building green is looking for sustainable, recycled, and recyclable materials. Recycled or refurbished materials are preferable, as the energy used to manufacture building products equals five to seven percent of U.S. energy consumption, according to the Natural Resources Defense Council (NRDC).

Agencies like the EPA and the U.S. Green Building Council offer resources to educate us about creating greener, carbon neutral structures. "Green" buildings use "less energy, water, and natural resources," says the U.S. Green Building Council, translating to lower energy and water bills for you and reduced greenhouse gas emissions in the environment. Whether you're designing, remodeling, or

demolishing a building, you can incorporate their eco-friendly ideas.

A good starting point is the Leadership in Energy and Environmental Design (LEED) Green Building Rating System. Their guidelines help you to determine your existing structure's environmental impact and provide direction on how to build a greener home, office, or commercial property at a cost comparable to conventional buildings. LEED-Certified buildings are exceptionally green buildings, and it takes considerable effort to achieve this honor.

An example of a LEED-Certified building is Helios House in Los Angeles, a concept gas station from BP which incorporates green building materials including "cradle to cradle" (made with waste-free production) stainless steel, recycled glass-in-concrete flooring, recycled scrap metals, 90 solar panels, and farmed wood from renewable sources. They also have a green roof (see Step 23) to help with insulation and cooling, and a structural design for maximum natural lighting to reduce energy use.

The NRDC office in Santa Monica is one of the rare buildings in America that has received a LEED platinum rating. Some of its features include light colored roofing to absorb less heat, a grid-connect solar electric array, extensive natural lighting, 95 percent recycled gypsum drywall, Forest Stewardship Council (FSC)-certified wood doors, and bamboo laminate flooring. Its designers used recycled materials including mineral fiber ceiling tiles, glass tiles, composite countertops, and nylon carpeting containing roughly 30 percent recycled nylon scrap. The restroom flooring contains fly ash, a byproduct of coal burning, and the elevator interior panels contain wheat straw, a byproduct of wheat harvesting. The exterior and interior siding is made from HardiePlank, a durable wood substitute made from cement and sawdust that doesn't shrink or expand, so it can

hold paint three times longer than wood. And a final impressive detail: the restroom partitions are made from 100 percent post-consumer recycled polyethylene milk containers.

The movie set of *Evan Almighty* provided an excellent example of recycling building materials after demolition. Director Tom Shadyac attempted to produce a completely carbon neutral film, which was fortunate due to the tremendous amount of building materials used to create the giant ark and houses on the set, all of which were built from scratch. After production, all of the lumber, landscaping, windows, flooring, hardware, and other reusable materials from the ark and the houses were donated to Habitat for Humanity (a group that builds houses in partnership with people in need), instead of being scrapped. The carbon emissions from building and production were also counted and offset by planting 2,050 trees.

In your own home-building or home-buying adventure, reducing your construction-related carbon emissions begins with being aware of your options. From the floor up, choose materials that are easy on the environment. Green flooring materials include cork, bamboo, and eucalyptus, all considered renewable materials because they take less time to grow than traditional hardwoods. Earth-friendly and affordable alternatives to wood include linoleum, recycled-content tile, and non-VOC (volatile organic compounds) carpet.

Using carpet squares makes cleaning and replacement easier and saves the energy and expense of replacing the entire carpet when a portion of it gets stained. The squares are easy to install and do not need to be backed by toxic padding like traditional carpet.

There are a number of excellent green-minded flooring companies. Eco Timber sells sustainably

harvested and reclaimed wood products. Flor and Shaw manufacture green carpet materials, made from recycled carpets and plastics. Forbo offers petrochemical-free flooring from natural materials. And Interface, Inc. is the world's largest carpet manufacturer of modular carpet, carpet tiles, and carpet squares.

When choosing wood for walls and cabinetry, be sure to look for wood products harvested from sustainably managed forests; such as those certified by the FSC.

Home Depot sells more FSC-certified EcoTimber than any other retailer. Their new Eco Options brand consists of more than 3,000 products store-wide with less of an impact on the environment than competing products in terms of energy efficiency, water conservation, and sustainable forestry.

Buying locally sourced products when possible also cuts down on carbon emissions associated with transporting heavy building products from farther away.

Once you've purchased your eco-friendly building materials, you'll want to keep the rest of your building green by paying attention to the details, including paint and furnishings. Paint is commonly made with petrochemicals that off-gas for the lifetime of the paint, potentially causing harm to inhabitants while adding to the global warming effects caused by petrochemicals. Using a low-VOC paint, available from most major paint brands, can keep unnecessary global warming–producing pollutants from escaping into the air.

When decorating your home or building's interior, consider using refurbished materials. Every time you buy furniture from a secondhand store, or renew old furniture with eco-friendly wood oils and paints instead of buying new pieces, you cut down on your environmental impact.

Look at sites like www.hgtv.com and www.ecofabulous.com for more suggestions on how to create great green interior design.

Greening the buildings where we live and work will improve our health and give us greater harmony with our surroundings. By taking this step, you will also help to save forests and continue to reduce your greenhouse gas count.

Resources

- www.bp.com
- www.ecofabulous.com
- www.ecotimber.com
- www.epa.gov/greenbuilding
- www.flor.com
- www.forbo.com
- www.fsc.org
- www.greenerbuildings.com
- www.hgtv.com
- www6.homedepot.com/ecooptions
- www.interfaceinc.com
- www.nrdc.org
- www.shawfloors.com
- www.usgbc.org

STEP #25
Green Your Office

You know those helpful tips for the home, like "Turn off lights when you leave the room?" Make sure to apply this logic at your workplace as well! There's a lot of power wasted at our offices that makes our planet the teensiest bit warmer day by day. As an employee, you can't control all aspects of your office environment, but you can make a significant impact. Here are some simple things you can do to make your workplace (or home office) a greener place to be:

- Instead of using and offering clients dozens of single-use plastic water bottles and cups each week, use glasses, mugs or reusable water bottles instead.
- Introduce organic coffee to your workplace (see Step 11, Buy Organic Fair Trade Coffee). You might even be able to get the office to make a permanent switch!
- Institute an office-wide recycling program by placing receptacles for recyclable paper near fax and copy machines and for cans and bottles in the kitchen.
- Consolidate your fax, printer, and copier into one machine. Amp up the energy savings even more by purchasing Energy Star–certified office equipment. According to the Co-op America website, if all of America's smaller offices bought Energy Star–certified equipment, we would eliminate 2.3 billion pounds of carbon dioxide, the equivalent of taking 807,000 cars off of the road.

- Before leaving the office, turn off all lights, water coolers, and office machines. Keep your electronic devices on a powerstrip to make shutting down the power as easy as a flip of the switch. Check out products like KILL-A-WATT (from P3 International) and CO_2 Saver for further energy savings.
- As a company, consider offsetting your CO_2 for a specific event, business trip, or venture, or for all of your production and operations (see Step 48, Buy Carbon Offsets).

As computers are the powerhouse for most office tasks, they deserve a closer look in terms of their carbon footprint:

- Simply turning off your computer at the end of every day will save about one ton of CO_2 per year. According to Earth 911, "If every U.S. computer and monitor were turned off at night, the nation could shut down eight large power stations and avoid emitting 7 million tons of CO_2 every year."
- Set your computer to go into sleep mode after 15 minutes (or less) of inactivity. In sleep mode, a computer uses 70 percent less energy than when the screensaver is active.
- By using a laptop instead of a desktop, you can save considerable energy. If you use a desktop, opt for a flat screen LCD monitor, which is more energy efficient than a bulky CRT.
- Consider using a Mac, which uses less electricity than the average PC.

Many workplaces have been the scene of the crime for a tremendous amount of needless paper waste. Here's an opportunity to make a major impact:

- You may want to begin by putting a picture of a tree or rainforest above the paper cabinet as a constant reminder to reduce your use.

- Whenever possible, rely on e-mail to avoid printing, copying, and faxing.
- Print on both sides of the page to cut your paper use in half.
- Circulate lengthy reports instead of printing out one for each person.
- Create more concise marketing materials. Remember less is often more, and often clients appreciate having fewer materials to carry around and file later.
- Buy only recycled paper for your office machines, preferably at 100 percent PCW (see Step 10, Buy Recycled Paper Products).
- Re-use the back side of non-confidential documents as scratch paper or for taping expense report receipts.
- Instead of standard petroleum-based inks, use soy-based inks which are better for your health and easier to de-ink during the recycling process.

There's a big opportunity to reduce carbon emissions when it comes to work-related car travel:

- Carpooling just two days per week can cut 1,590 pounds of CO_2 emissions annually, and even more for each additional person. Sharing rides to work drastically reduces fuel costs, puts less wear and tear on your car, and can get you to work in shorter time, thanks to carpool lanes. Carpooling also gives you an opportunity to build friendships and business relationships, and often is quite fun, making even long commutes breeze by! Many larger companies assist their employees in arranging carpools and vanpools, and some offer modest financial incentives as well. If you can't find a coworker who lives near you, consider looking for a transportation buddy at www.carpoolcrew.com—you can even search for someone with a similar taste in music!

- Telecommuting (working from home) is a powerful way to cut down on emissions. Don't overlook this option. If we all worked at home just one day per week, we'd cut 143 billion pounds of CO_2 per year, according to thegreencurve.com.
- As an alternative to flying or driving to meet with out-of-town or out-of-country clients or coworkers, consider video teleconferencing. This great alternative to in-person meetings saves time and money by eliminating the need for car and air travel, yet still allows for virtual face-to-face conversations.

By maintaining a green office, not only will you reduce your carbon footprint, you will set great eco-examples for everyone who visits your office, including your coworkers, employees, and clients.

Resources

- www.carpoolcrew.com
- www.coopamerica.org
- www.co2saver.snap.com
- www.earth911.org
- www.ecoshoppe.com
- www1.eere.energy.gov/consumer/tips/lighting.html
- www.p3international.com
- www.thegreencurve.com

STEP #26
Give Green
Gifts

If you are going to a party and want to bring a gift for your host, why not select an original, memorable gift that will help the planet and possibly inspire everyone who admires it—a green gift. Giving green gifts is a great way to spread knowledge about how to reduce our carbon footprints. Just about any gift you imagine can be given greenly, from food and wine (see Step 19) to home décor, jewelry, and clothing (see Step 13).

In this day and age of ecological awareness, giving green gifts is easier than ever, thanks to the Internet. Here are a few sites selling products that make excellent green gifts:

- Ecoist.com offers fair trade handbags and housewares made from repurposed paper goods like food packages, candy wrappers, and movie billboards.
- Ecoexpress.com has the slogan "uncommon gifts for the common good." They have everything from eco-friendly solar-powered gadgets to organic fruit and nut baskets.
- Ecoshoppe.com was founded by Greg Horn, author of *Living Green: A Practical Guide to Simple Sustainability*, and offers a fun assortment of green gifts, as well as innovative green products for your home and office.
- Gaiam.com offers an impressive variety of organic products as well as practical and luxurious green gifts for the mind, body, spirit, and home.

- For beautiful and functional glassware made from 100 percent post consumer recycled glass, visit the Green Glass Company website (www.greenglass.com). Also check out custom jewelry made with found sea glass from By the Sea Jewelry.
- Grounds for Peace offers necklaces formed from used coffee grounds. The sculpted works of art even smell a bit like coffee, delivering an aromatic jolt throughout the day.

Whenever possible, it's a great idea not to gift a brand new item, but to give an activity, service, or gift certificate. Consider these green-gifting options:

- An America the Beautiful National Parks and Federal Recreational Lands Annual Pass allows free entrance for one year into federally managed public lands, including the National Parks. The pass can be purchased at www.recreation.gov.
- Make a donation to the recipient's favorite charitable organization, or introduce them to an organization that matches their interests and values. For example, you can symbolically adopt a wild animal or a rainforest in the recipient's name (see Step 22).
- Purchase a membership to a local museum, theater company, botanical garden, or other similar organization.
- Put together an organic picnic basket to enjoy a day in nature. You might want to include a blanket from www.bluelotusblankets.com, made with a fiber called Fortrel EcoSpun™, produced from 100 percent post-consumer recycled plastic bottles.
- Give a gift card. While sometimes judged as unimaginative, gift cards are actually very environmentally responsible, when you consider the amount of carbon emitted and trees felled in the production of unwanted gifts each year. Gift cards

also don't require wrapping and in some cases are reusable.

- Although re-gifting is traditionally considered taboo, it is one of the greenest gifts you can give. Break tradition and pass on something special, like a family heirloom. Or spruce up something the recipient has always admired. Your thoughtfulness is sure to be appreciated.

Once you have your green gift, be sure the wrapping is environmentally responsible as well. We will save many forests when enough of us implement green gift-wrapping ideas such as these:

- Reuse sturdy gift boxes and bags. Be sure to purchase ones that are attractive, so they will be reused again and again.
- Buy recycled, post-consumer content wrapping paper, or hemp wrapping paper, available from www.eartheasy.com/gift_wrapping.htm.
- Use another usable item to wrap with, such as a scarf or decorated handkerchief.
- Reuse newspaper comics or pretty pictures from old calendars as wrapping paper.
- Look for companies like Eco Express, who send their gifts in attractive, earth-friendly packaging.
- Create decorative fabric gift bags. (Visit www.eartheasy.com/gift_wrapping.htm for easy instructions to make them yourself.) These special gift holders can be reused again and again, and may even start a fun tradition when passed around among family and friends. Buy cloth gift bags from Patagonia, $2 each, these bags are made of excess material from the cutting room floor.
- Simply add a large bow to hard-to-wrap items, or dare to present your gift without wrapping. You can still have the recipient close their eyes, for the

surprise effect. Or consider foregoing gift wrap for a treasure hunt, complete with clues that lead the recipient to the present.

When it comes to gifts, people often say, "It's the thought that counts." Green gifting is a significant way to help protect the future of everyone on the globe. Now that's thoughtful!

Resources

- www.bluelotusblankets.com
- www.bytheseajewelry.com
- www.eartheasy.com/gift_wrapping.htm
- www.ecoexpress.com
- www.ecoist.com
- www.gaiam.com
- www.greengiftguide.com
- www.greenglass.com
- www.groundsforpeace.com
- www.organicbouquet.com
- www.patagonia.com

STEP #27
Clean Up Your Indoor Air

When combating global warming, our goal is to clear the air of greenhouse gases. We're all aware of the outside haze of pollution from planes, trains, automobiles, and factories. But did you know that the air inside is often even more polluted? By changing the products that we purchase for our home, we can clean up our indoor air and contribute to the change in global air composition as well. Indoor air can be filled with petrochemical off-gassing, not to mention molds, smoke, formaldehyde, and radon. These pollutants can contribute to everything from asthma to lung cancer, to heart disease to, you guessed it, global warming.

One simple way to improve your indoor air is to take a look at your cleaning products. Instead of using harsh industrial chemicals (including bleach and amonia), use natural cleansers like baking soda, hydrogen peroxide, borax, and vinegar. These alternatives can be used for everything from washing windows to disinfection, and they don't release gases and contribute to global warming the way mass-marketed products do. (See Step 14, Use Petrochemical-Free Household Products.)

Another recommended step is to change your indoor air filter on a regular basis. This can help collect dust particles, allergens, pollen, and pet dander that you would otherwise inhale, plus it can do wonders for carbon consumption. According to climatecrisis.net, cleaning a dirty air filter can save 350 pounds of carbon dioxide a year. Home air filters work by keeping the coils and heat exchanges on the

heating and air conditioning system clean. Dirty coils and heat exchanges make the system work harder, so keeping the filter clean will not only help prolong the life of your HVAC (heating, ventilation, and air conditioning) unit, it will also help it to work more efficiently, using less energy and creating less carbon.

A quality air purification system is also important for optimal air quality. HVAC air filters can only do so much. *The Doctors' Prescription for Healthy Living* has reported that the Pionair air treatment system from HealthQuest Technologies is perhaps the best at removal of volatile organic compounds (VOCs) and particulate, plus it is among the lowest in energy consumption, and it is quiet and requires little maintenance. You may also want to have your house checked for radon, a gas known to cause lung cancer. If the levels are too high, the situation will need to be professionally remediated.

Plants have also been studied as a potential indoor air cleaner, and they naturally thrive by converting CO_2 into oxygen. Some of the best species for ridding the air of CO_2 include English ivy, heartleafed philodendron, and green spider plants. Houseplants are a wonderful choice for freshening up your indoor environment, but do be aware that over watering houseplants may promote the growth of microorganisms in the soil, leading to potential health problems, especially for people who are sensitive to molds.

By simply being aware of the factors that pollute your indoor environment, you can take steps to clean it up!

Resources

- www.climatecrisis.net
- www.epa.gov
- www.holistichelp.net
- www.pionair.net

STEP #28
Be An Energy Star Consumer

You've seen the commercials for Energy Star and its symbol on the corners of your friends' and families' appliances and electronics. But you still may not be quite sure what Energy Star is, or how it could help the environment and the global warming situation. The following information can help you understand the importance of being an Energy Star consumer.

The Energy Star label is an easy way for consumers to recognize appliances and electronics that require less electricity to operate, thereby reducing greenhouse gas emissions that come from fossil fuel-burning electrical power plants. The Energy Star program was started through the joint efforts of the EPA and the U.S. Department of Energy to help consumers save money while reducing GHG emissions. The EPA has now placed the label on everything from light bulbs to refrigerators, microwaves, and entire houses built according to environmentally sound guidelines. By being an Energy Star consumer, you help to reduce the effects of global warming every time you do something as simple as turning on your Energy Star television set, instead of the rabbit-eared model you inherited.

Since its inception in 1992, as a means of saving energy used by computer monitors, Energy Star has expanded to help business owners have more energy-efficient offices and homeowners have more energy-efficient homes. To date,

Energy Star has reduced emissions levels to the equivalent of taking several million cars off the road each year.

To qualify for an Energy Star seal of approval, a product must meet strict requirements for energy efficiency. Each product must also pass Energy Star's testing every year to be labeled Energy Star worthy. Even if a laptop passed one year, it may not qualify the next, depending on the energy-saving requirements for that particular product.

When you visit the Energy Star website, you will find more than 50 categories of energy-saving products, including small appliances like battery chargers and water coolers and large appliances like dishwashers, washers, dryers, and refrigerators, just to name a few. Energy Star is also present in the workplace in the form of computers, copiers, fax machines, printers, scanners, and other electronic office devices. Energy Star products are not limited to personal consumer use, but include large commercial products as well. Energy Star also sets standards for building materials, including roofing products, insulation, windows, doors, and skylights. An Energy Star home means it has been built with high standards for reduced non-renewable energy use.

As an added incentive to consumers, many Energy Star partners across the nation offer rebates and special offers. At certain times, utilities and manufacturers offer up to a $1,000 discount on Energy Star products. Type in your zip code and appliance on the website to find out whether or not you qualify for a rebate or special offer. The IRS also offers tax credits for more expensive Energy Star products, thereby helping to reduce your cost, by reducing your income tax. You can find out more at www.energystar.gov/index.cfm?c=products.pr_tax_credits.

Remember, by being an Energy Star consumer, you will help to save the planet from global warming by reducing

greenhouse gases and reduce money spent on your energy bills as well!

Resources

- www.energystar.gov
- www.energystar.gov/index.cfm?c=products.pr_tax_credits
- www.energystar.gov/index.cfm?fuseaction=rebate.rebate_locator

STEP #29
Buy Organic Supplements

You may think of nutritional supplements, such as vitamins, as one of the last things to affect global warming. However, Americans are consuming a tremendous amount of supplements—almost $8.7 billion worth in 2005—as more of us are being proactive about our health. Buyer beware, however, as not all nutritional supplements are environmentally sound.

Many dietary supplements use ingredients derived from petrochemicals (chemicals made from petroleum) or grown using harmful pesticides and chemical fertilizers which contain petrochemicals, thus, adding considerable amounts of global warming–contributing gases to our environment.

By spending our shopping dollars on organic nutritional supplements, we avoid the production and use of petrochemicals, reduce greenhouse gases, and support fair trade organic agriculture that leads to the preservation of natural lands.

Petrochemicals are often used because they are less expensive than natural ingredients. However, if more consumer dollars were spent on organic supplements— including the $3.29 billion spent by Americans in 2005 on vitamins and $272 million spent on homeopathic medicines, as reported by www.naturalfoodsmerchandiser.com—it would make a huge impact on the nutritional supplement industry. More companies would be motivated to produce organically, and they would create less carbon greenhouse emissions overall.

Wouldn't you much rather buy the neem (a tree product) you use as an antifungal from an organic farmer than from a company mass-producing it with chemical pesticides? Supporting the small organic farms that strive to make a difference keeps our planet healthier and fends off global warming.

Here are some great organic supplement companies to get you started:

- **New Chapter** is a small, Vermont-based company providing food-based supplements made without synthetics or fillers. They grow their plants and herbs on an organic, sustainable farm in Costa Rica. Their lush acres provide a home for insects, butterflies, and monkeys that are never in danger of harm from inorganic farming methods; they even use oxen instead of emissions-producing machinery.

- **Flora**, one of the premiere organic herb companies, is affiliated with Salus Haus in Germany which operates on virtually self-supplied renewable energy, producing zero waste and earning highest rankings in the European ecological directives.

- **Barlean's Organic Oils** is one of the largest purchasers of homegrown, 100 percent organic North American flaxseed in the United States today. This family run company buys at a fair price and delivers a superior tasting, organic, and fresh product.

- **Garden of Life** is another excellent supplement company devoted to using organically grown ingredients and to ensuring that their products contain nutritious, easily digestible whole foods.

- **Gaia Herbs** grows their plants and herbs according to the extremely stringent Oregon Tilth organic certification program requirements, on a 250-acre certified organic farm in North Carolina. Even the

buildings on their farm property were built to be as environmentally friendly and non-toxic as possible.

Every time that you support supplement companies that use organic ingredients, you are contributing to the growth of organic farms that use growing techniques that don't pollute or contribute to global warming. And the health-promoting products that you purchase, being free of petrochemicals, will be safer for you as well.

Resources

- www.barleans.com
- www.florahealth.com
- www.gaiaherbs.com
- www.gardenoflife.com
- www.herb-pharm.com
- www.naturalfoodsmerchandiser.com
- www.new-chapter.com

STEP #30
Reduce, Reuse, Recycle

Learning the three Rs has always been important. Today, the new green three Rs—Reduce, Reuse, Recycle—ring in our ears like a mantra for present times.

If we can reduce the amount of things we buy and energy we use, reuse the resources we already have, and recycle all of our paper, cardboard, plastics, and metals, we will make an incredible impact on our environment. We can keep greenhouse gases from being produced and preserve more of our natural resources, including trees, so they will continue absorbing carbon dioxide from our air.

Although the phrase, "Reduce, Reuse, Recycle" is familiar to most people, many may not realize that these actions are listed in priority order. *Recycling* should be the last resort.

Disposable plastic water bottles are a good example. Many people do not realize that almost all plastics are made from petroleum, so it's a good rule to buy and use as few plastics as possible. The Container Recycling Institute tells us that it takes more than 1.5 million barrels of oil a year (enough fuel for 100,000 cars for a year) to make enough water bottles just for people in the United States alone. Transporting and disposing of them add to the environmental strain water bottles cause.

We can reduce the number of water bottles we buy simply by drinking tap water and by refilling sturdier, reusable water containers. If we all did this, think of the millions of barrels of oil we'd save!

The "reduce" principle goes for all disposable items. Opt for quality rather than throw-away items for purchases like cameras, plates, and razors. Use commuter mugs for your coffee and reusable shopping bags rather than plastic bags. Plastic bags do not biodegrade and often end up in our oceans and waterways. If you must buy disposables, go for the recyclable products with the least amount of packaging.

Supporting businesses that are practicing the "reuse" principle by using recycled containers and packaging encourages other companies to join the trend. One company setting a great example is Recycline—they create toothbrushes, razors, and plastic tableware from 100 percent recycled plastic, including recycled Stonyfield Farm yogurt cups.

In 2004, Starbucks announced it would use partially recycled paper coffee cups and began offering a 10 percent discount for BYOM (bring your own [coffee] mug) customers. They also offer complimentary five-pound bags of coffee grounds, "Ground for Your Garden," to customers who want to use them for mulch.

While more companies are using recycled materials in their products than ever before, the majority have yet to catch on. If your cereal box or milk bottle is made from 100 percent recycled paperboard or glass, then you reward, support, and grow the recycled products industry simply by buying that particular product. If the label isn't clear on whether the product or package is made from recycled materials, ask your merchant or call the manufacturer to find out. Remember, as a paying consumer you wield a lot of power! After a certain number of customer calls, any smart company will investigate switching to recycled packaging.

It's important to understand that even recycled products may not be as green as they could be if they aren't readily reusable and recyclable again (and again). For example,

specialty jackets made from recycled plastic bottles cannot be recycled further. They cannot be recycled back into plastic milk jugs or into new jackets. They are, despite being made from recycled materials, destined for the landfill after the jacket wears out. Pioneering green architect and product designer William McDonough refers to this limited recyclability as "downcycling." He posits that true recycling involves a plastic jug, cereal box, or razor blade being made into those same things over and over and over again.

Even better is "upcycling"—taking something disposable or recycled and turning it into something of greater, greener, more lasting value. For example, home design supply companies like EnviroGlas and Vetrazzo use recycled glass to make gorgeous colorful countertops and floors.

In terms of recycling, many of us recycle with our eyes closed these days, having formed the habit during past decades. Our city, county, or private trash haulers often supply us with bins for convenient curbside recycling, making it easy for us. Waste Management, America's largest solid waste company, was the first to focus on residential single-stream recycling, which allows customers to mix recyclable paper, plastic, and glass in one bin. They found that residential single-stream programs have greatly increased recycling rates, recovering as much as three times the amount of recyclable waste.

However, half of U.S. households still do not have curbside recycling, which may account for some of the 3,633 million pounds of recyclable water bottles in the U.S. that ended up in the landfill in 2004. In some locations, you can pay extra to have bins for recycling and for biowaste (garden and food waste). Where this isn't an option, you can deliver your recyclables to a nearby recycling facility (we know this is inconvenient, but your great grandchildren will be glad you

did), or you can e-mail your legislators about increasing curbside recycling and adding more recycling centers.

Visit the National Recycling Coalition website for the 10 most important items to recycle and the top 10 reasons to recycle. One reason is that decomposing waste in landfills releases carbon dioxide and methane gas into the air. In 2000, by recycling solid waste, Americans prevented the release of 32.9 million metric tons of carbon equivalent (the unit of measure for greenhouse gases) into the air. Looking back several decades, we have progressed by leaps and bounds in the amount of trash we recycle. Let us continue this momentum to gain our victory over global warming!

Resources

- www.container-recycling.org
- www.enviroglasproducts.com
- www.epa.gov/epaoswer/
 non-hw/muncpl/buyrec.htm
- www.mcdonough.com/cradle_to_cradle.htm
- www.nrc-recycle.org
- www.recycledproducts.org
- www.recycline.com
- www.starbucks.com
- www.sustainablepackaging.org
- www.vetrazzo.com

STEP #31
Have Your Groceries Delivered

B y now you know that the biggest contributor to global warming is from carbon dioxide, which comes in large part from vehicle emissions. Consolidating the number of cars and trucks on the road will help stop global warming and radically reduce our dependency on foreign oil.

An especially easy way to reduce the number of vehicles on the highway is to save yourself a trip and have your groceries delivered to you. The delivery vehicle will make multiple stops in your neighborhood, reducing the number of miles driven overall, and relieving the streets of traffic jam–inducing and carbon-emitting cars.

Most major supermarket chains including Vons and Safeway now offer free or discounted delivery on larger orders. They also stock many organic foods produced without the use of petrochemical pesticides that contribute to global warming. So you can buy healthy food, save time, and reduce air pollution all at once.

For organic goods delivered fresh to your door, consider Diamond Organics. They have an array of fresh organic and sustainably produced products delivered via FedEx from their Northern California headquarters. For added convenience, the company allows customers to create a custom standing order.

Grocers throughout North America are jumping on the home-delivery bandwagon. Here are some to try:

- In California, try Organic Express.
- In the Chicago area, take a look at peapod.com.
- In the New York area, check out freshdirect.com.
- In North Charleston, South Carolina, Healthy Home Foods provides fresh delivery options.
- In Orlando, Florida, check out Orlando Organics.
- In the San Francisco Bay area, look into Westside Organics.
- In Seattle, check out Pioneer Organics.
- In Toronto, Vancouver, Burnaby, and Richmond, Canada, look at Green Earth Organics.
- In Vancouver and Victoria, British Columbia, check out Small Potatoes Urban Delivery (SPUD).

Having your groceries delivered is a convenient way to save excess emissions from multiple cars while giving you more time for yourself, your family and friends, and the carbon neutral activities you enjoy!

Resources

- www.diamondorganics.com
- www.freshdirect.com
- www.greenearthorganics.com
- www.healthyhomefoods.com
- www.organicexpress.com
- www.orlandoorganics.com
- www.peapod.com
- www.pioneerorganics.com
- www.safeway.com
- www.spud.ca
- www.vons.com
- www.westsideorganics.com

STEP #32
Take an
Eco-Vacation

When we take a break from our daily green routines, we don't have to leave our eco-friendliness behind. We can show our true colors (green!) by applying our environmental awareness to our vacations, be it an All-American road trip or an out-of-country extravaganza.

Eco-vacations have become so popular that even online travel sites like Orbitz have a site (www.eco.orbitz.com) devoted to planning your eco-vacation. You can search hotels or packages, just as you do for any other vacation, with the added bonus of knowing how eco-friendly your hotel will be, for example, the use of energy-saving light bulbs, organic bedding, and earth-friendly bath products.

An eco-friendly vacation can start with something as simple as renting a hybrid (www.evrental.com) or biodiesel powered car (www.bio-beetle.com) and hitting the open road. How much of America have you and your family actually seen and experienced? Vacationing in America keeps our economy strong, and traveling by ground cuts back on the hundreds of tons of CO_2 released by air travel. Of course trains are another fun and earth-friendly option for traveling cross country.

The David Suzuki Foundation points out that, "compared to other modes of transport, such as driving or taking the train, travelling by air has a greater climate impact per passenger kilometer, even over longer distances." Although it is a relatively small industry, aviation accounts

for 4 to 9 percent of the total climate change impact from human activity.

For the times when air travel is unavoidable, www.climatecare.org and www.nativeenergy.com/travel provide calculators to determine your vacation's carbon emissions, as well as ideas and means of offsetting the carbon impact of your travel. (See Step 51 for more information on carbon offsets.)

Although it is not as glamorous as renting a hybrid or flying first class, taking the Greyhound is a great way to share your emissions output. As a bonus, you get to see and meet a lot of interesting people who might not otherwise cross your path.

Once you've decided how to get there, you can look at the Green Hotels Association's website (www.greenhotels.com) for a list of lodgings with green standards in nearly every state. The site provides mini summaries of each hotel's provisions as well as contact information.

Especially notable is the Kimpton Hotel chain, whose mission is to support sustainability through non-intrusive, high-quality, eco-friendly products and services. They use environmentally friendly cleaning products, print with soy inks on recycled paper, serve organic beverages, and suggest that guests reuse their towels and linens. They also use low-energy light bulbs, low flow water systems, paperless check-in/outs and coat hanger recycling. You won't find any styrofoam cups at Kimpton, but you will find organic flowers, organic snacks, and in-room designer recycling bins, along with recycled glassware and organic bedding in the gift store. It's no surprise that Kimpton has won many awards including the National GeoTourism Award, the American Hotel & Lodging Association's Good Earthkeeping Award, and the State Model for Conservation Award from the State of California's Green Lodging

program. Kimpton is setting an excellent example and the more we support them, the more other hotel chains will follow.

If you would like to spend your eco-vacation actively helping the planet, look for group tours and volunteer opportunities offered by environmental organizations. Working eco-tours are a great way to learn about other cultures, while helping the planet too. The Sierra Club offers several opportunities for eco-travel, ranging from around the United States to as far away as Antarctica. Of course, the further you travel, the more it is likely to cost in dollars and emissions output.

For an especially eco-friendly, ultra-healthy, and economical vacation, check out Worldwide Opportunities on Organic Farms (WWOOF) at www.wwoof.org. This organization provides people with volunteer opportunities to work on organic farms and learn about growing fruits and vegetables as well as building everything necessary to make these farms operate without the use of the chemicals and pesticides that contribute to global warming. Some farms provide food and lodging, while others request you bring your own tent. WWOOF gives you the names and contact information, but it is up to you to find out the details of what you need to bring and what the farm will provide.

For an international list of eco-vacations, check out The International Ecotourism Society (TIES) at www.ecotourism.org, where you will find a list of places to explore in a green-friendly manner and guidelines about how to behave and what to expect once you arrive at your destination. This is important, as many times, the most popular ecosystems are found in countries that depend on the economic benefits of tourism, but also have few environmental protection policies in place.

TIES helps you ensure you make a positive impact by providing you with everything you need to know about having a responsible eco-vacation, and connecting you with green travel agents, lodging, and transportation services on literally every continent.

As you can see, escaping from your everyday routine doesn't have to mean more emissions output, as there are plenty of eco-vacations that can help keep global warming in check.

Resources

- www.bio-beetle.com
- www.climatecare.org
- www.davidsuzuki.org
- www.eco.orbitz.com
- www.ecotourism.org
- www.evrental.com
- www.greenhotels.com
- www.kimptonhotels.com
- www.nativeenergy.com/travel
- www.sierraclub.org
- www.wwoof.org

STEP #33
Look for Fair Trade

The fair trade movement seeks to provide fair labor conditions, living wages, and improved quality of life to workers who might easily be exploited and to protect environments and ecosystems that provide precious resources for the global community. By purchasing items that are Fair Trade Certified, you help protect our natural resources and help protect vulnerable populations as well.

According to transfairusa.org, one of the key fair trade principles is environmental sustainability: "Harmful agrochemicals and GMOs (genetically modified organisms) are strictly prohibited in favor of environmentally sustainable farming methods that protect farmers' health and preserve valuable ecosystems for future generations."

FINE, an unofficial conglomeration of the top four fair trade networks, explains that "Fair trade organizations (backed by consumers) are engaged actively in supporting producers, awareness raising and in campaigning for changes in the rules and practice of conventional international trade."

Buying fair trade products and supporting fair trade efforts and organizations supports the needs of marginalized people, including access to clean air and water that are often compromised by activities like mining and oil drilling.

According to Oxfam, a worldwide organization seeking to better the lives of people who live and work under the harmful conditions produced by mining and oil drilling,

mining releases toxic fumes and dusts which settle on local agriculture and water sources, causing cancers, birth defects, and other health problems. In addition, mines require large amounts of water to operate, and tend to win out over crops and people who also need the scarce resource. Oil drilling also causes significant damage to native environments. Where there is oil, there is often an influx in human activity, including road-building that tears up fragile ecosystems and causes toxic chemicals to be released into the soil and water supply, harming agriculture and marine life. Even more, oil wells often burn natural gas, contributing significant amounts of emissions to global warming.

By supporting Oxfam and buying fair trade products, you can be a part of the solution to help the plight of indigenous peoples and also promote education about the importance of environmentally sound production processes.

TransFair USA is another organization that explores fair trade practices and the environmental importance of buying fair trade products. According to their website, in order to receive a fair trade certification, a product must be produced adhering to stringent environmental standards that protect the environment and its people from harm.

These standards require that harmful agrochemicals are kept away from fair trade crops so that the soil and land have long-term sustainability, and they protect people from coming in contact with or ingesting potentially harmful chemicals that can be released into the air and contribute to global warming. Crops must be rotated and careful attention paid to the use of water. Burning land is not an option unless it is found to be ecologically sound (in commercial agriculture, land is burned to make room for crops, releasing carbon dioxide and carbon monoxide— both greenhouse gases—into the air and making long-term use of the land nearly impossible).

TransFair USA says fair trade methods of growing promote the following:

- **Biodiversity:** Forested regions are some of the most threatened environments on our planet. We rely on these regions to rid the air of harmful greenhouse gases and turn them into oxygen. By growing small crops of coffee and cocoa in these regions, small ecosystems are maintained.
- **Shade grown:** By growing coffee and cocoa in the shade, native habitats are preserved (see Step 11, Buy Organic Fair Trade Coffee).
- **Organic:** Although not all fair trade products are certified organic, farmers are required to practice alternative pest-control methods, eliminating a lot of the agrochemicals that pollute the air and earth.
- **Sustainability:** Fair trade encourages a minimum of waste and the use of reusable resources like composting rather than dumping harvest waste materials.

You can buy fair trade–grown products from numerous retailers like coffee chains and grocery stores nationwide; you can find a complete list at www.transfairusa.org/content/WhereToBuy.

By participating in fair trade, you help lessen the impact of global warming caused by unsustainable methods of mining, oil drilling, and farming.

Resources

- www.oxfam.org
- www.transfairusa.org
- www.transfairusa.org/content/WhereToBuy

STEP #34
Turn Off Your
Air Conditioner

As global warming increases and heat waves intensify in many areas around the globe, the easiest way to beat the heat is by turning on an air conditioner. However, air conditioners require large amounts of electricity, generated by burning fossil fuels—the primary human source of carbon emissions—which in turn contributes to global warming. It's a vicious cycle, and the best way to stop it is simply to turn off your air conditioner!

Air conditioners are responsible for about one-sixth of electricity used, or 43 percent of the peak electric power load on a hot summer day, according to eartheasy.com. Cooling and heating systems in the U.S. emit over a half billion tons of carbon dioxide into the atmosphere each year, and 17 percent of greenhouse gas emissions come from household electricity use, according to the U.S. Department of Energy. So finding alternative ways to keep cool is essential.

Adding to the energy and emissions issues is the fact that utility bills constitute the second largest household expense. Cooling down without the air conditioner can really add up to big earth-friendly savings. Eartheasy.com suggests the following tips for cutting emissions and saving cash:

- Insulate well to keep your home cool in hot weather and warm in cold weather. In the summer, much of the heat absorbed by a house comes through the attic floor. By insulating the attic floor, you can prevent a lot of heat from blazing down into the house. You

can also install double pane windows for extra insulation and caulk or weatherstrip doors and windows to prevent air leaks.

- Understand that house color plays a role in how much heat a house absorbs. Dark-colored homes absorb more heat than light-colored homes. If you can't repaint, offset the heat absorption by installing radiant barrier insulation.
- Use shading to cover your windows and cut up to 40 percent of your cooling costs. Drapes are the most effective means of blocking sunlight, especially on south- and west-facing exposures. Blinds are also a good measure of blocking sun, and you can use "black out" fabric (available at fabric stores) to even more effectively keep the sun out.
- Let nature work for you. Landscaping with trees and quick-growing vines in the hottest areas around your home provides a cool surrounding. Be sure to allow some space between the plants and your home for the cool space barrier. Native shrubs provide excellent sun blockage on the lowest points of walls where sun seeps in.
- Install roof vents. At $5-10 each, roof vents are an inexpensive way to help cool your home in the summer, without cooling your home during the winter.
- Install Coolvent on your roof. Coolvent is an inexpensive material that helps cool your attic and therefore your home as well and prevents wind-driven rain from entering.
- Change air filters in heating and cooling systems regularly to knock 2 percent off your CO_2 output each year.
- Install ceiling fans. They are a low-energy usage alternative to air conditioning because they use a lot

less power. Some models are also effective for winter use, as they pull warm air down from the ceiling.

- Avoid using incandescent (traditional) light bulbs which waste 75 percent of their energy use on creating heat! Instead use cool compact florescent light bulbs (CFLs).
- Air dry clothes instead of using the dryer. When clothes are hanging inside, they also have a natural cooling effect. When the weather is too cold for clothes to air dry, leave the door to the laundry room open, and the dryer will help to warm up the rest of the house.
- Air dry dishes to avoid using the heat cycle and wash only full loads to minimize energy use.
- Use a window fan when the air outside is not too hot. Be sure to leave doors and windows open to maximize air flow from this source.
- Turn off the gas supply to fireplaces and heaters during warmer months. Keeping a pilot light lit generates excess energy and it is easy enough to turn it back on in the fall.
- Close the chimney to minimize cool air loss from inside your home.

Your efforts on this simple step will lower your greenhouse gas emissions and are certain to lower your energy bills as well!

Resources

- www.eartheasy.com
- www.energy.gov
- www.epa.gov
- www.discoversolarenergy.com

STEP #35
Join an Environmental Group

You know the saying, "There is strength in numbers." This sentiment couldn't be more true than when it applies to joining an environmental group. Covering everything from local to national issues, environmental groups help protect the world's ecological networks and strive to educate and promote awareness. Joining a great green organization is fun and inspiring, and it will help you to achieve your own green goals. Your participation will also help to progress many green projects worldwide and spread awareness about the need to protect the environment from hazards like greenhouse gas emissions.

When looking for an organization to join, it can be helpful to visit several groups before making a commitment. See how much you enjoy the dynamics, organizational structure, and social "flavor" of each group. Then assess how closely the group's mission aligns with your own, and consider if the group's activities would be fulfilling to you, or if they would leave you wishing you could work on different projects.

If you are willing do some serious group "shopping," not only are you bound to find one that is a great fit for you, but you will also learn a lot about what various groups are doing, and you may have new ideas to bring to the outstanding group that you ultimately choose. And, yes, if it seems a bit intimidating to meet so many new people,

bring along a good friend. As you compare groups together, you will be able to share your observations, and your friend may notice things about each group that you missed.

While it is certainly most enjoyable to join a group that has local meetings or outings, you can also benefit from joining an online group or by finding a worthy group to donate to. Some of the most popular green organizations include the following:

- Greenpeace was started more than 30 years ago by a group of activists seeking to protect Alaska from nuclear testing by the U.S. government. The group won its fight and now seeks to protect the world from other environmental harms. You can help Greenpeace in their mission by blogging, donating, working, or volunteering. Greenpeace also offers special opportunities specifically for students and interns.

- Founded in 1951, The Nature Conservancy focuses on protecting the resources people and animals need to survive, by working tirelessly to preserve land and bodies of water, including conservation sites all over the world. Visit their website to learn more about this environmental group and its non-confrontational, science-based research efforts.

- The Sierra Club was founded in 1892 and has grown to encompass over one million people speaking up for the environment. One of the key ways the Sierra Club spreads its message is through outreach programs that get people out to enjoy the outdoors, including programs for inner city kids. One of the best ways to get people passionate about protecting Mother Nature is to foster a love for the outdoors.

- The Rainforest Action Network (RAN) leads campaigns to break America's oil dependency, and protects rainforests against destructive methods of

deforestation that endanger their inhabitants and the natural systems that sustain life. RAN offers opportunities to take action online and participate in local chapters across the country.

- The World Federation of United Nations Association (WFUNA) seeks to help the world's people live better lives and educates about climate change. WFUNA offers a variety of ways to be active in their organization, from participating in their online community to joining your local chapter.

- Greenenergytv.com is an environmental video-sharing site, similar in concept to YouTube. By uploading your personal success stories of how you are helping to squash global warming, you will be part of a group that literally shows how everyone can be green. Green Energy TV also uses some of its revenues to install solar and wind energy projects in Third World countries.

Of course, these are just a few environmental groups out of thousands in America. You can find others by surfing the Internet, reading environmental publications, or talking to your friends and neighbors. Stick with this step and you'll experience firsthand the power and hope of being united in purpose with others with the common goal of protecting our environment and halting global warming.

Resources

- www.greenenergytv.com
- www.greenpeace.org/usa
- www.nature.org
- www.ran.org
- www.sierraclub.org
- www.wfuna.org

STEP #36
Raise Your Voice for the Environment

Do you feel passionately about saving the planet for your great grandchildren? If so, don't be afraid to speak out! By raising your voice, setting a good example, and educating others about how they can take steps to reverse global warming, you will help turn the tide for our planetary problem.

How you spread the word about global warming prevention is not as important as just doing it! There are countless effective ways to get the green message out to the general public and to our elected officials who make decisions and pass laws that will affect global warming.

Blogging is a great way to make your voice heard by wielding the power of the keyboard. Short for weblog, a blog offers an interactive, online forum for airing your opinions and points of view. The media and politicians pay attention to blogs, most of which are updated daily and provide important information about pertinent issues and public opinion. Doing a Google search for "green blogs" or "political blogs" nets thousands of choices for places to post your thoughts (see Resources for a few of them).

Calling or writing your local representative or senator is another easy, effective way to make your views known. Each call, letter, and e-mail will be tallied by the official's staff and will help them to understand where their constituents stand on the issues. Most local, state, and federal representatives have websites, many of which feature user-

friendly feedback forms. You can find the mailing addresses and phone numbers for your local representatives at www.congress.org and for your senators at www.senate.gov.

You can also call or write corporations to request that they incorporate greener practices. You may want to suggest that they aim to meet the qualifications for the Green Patriot Green 100 companies (www.greenpatriot.us/green100.html) or praise them for environmentally responsible steps they are currently taking. You can find contact information for corporations at virtually every company website under the heading "Contact Us." For suggestions on how to compose letters to corporations or government officials, see Step 41, Send an E-mail a Day.

Don't underestimate the effect your letters may have. In the documentary The Corporation, Roy Anderson, C.E.O. of Interface (the world's largest carpet manufacturer), reported that consumers asking what Interface was doing for the environment inspired him to investigate the effects that his chemically treated carpets were having on the public and the environment, and since he has become a major force in the green movement himself.

Campaigning and voting for elected officials who share your green values also effectively gets your point across. The time you contribute to a green campaign—whether to pass a green proposition or to elect a candidate with a carbon neutral mission—is time well spent on behalf of our future generations. Project Vote Smart has a helpful website that shows how current elected officials are voting on environmental issues.

You can also be an advocate for the planet at all of the locations you frequent throughout the week. All you need to do is pay attention to what is happening around you, find your courage, and take the time to speak up. For example, as a member of an organization such as your

school or church, you can speak up by requesting recycling bins or by lobbying to reduce paper waste, use compact florescent bulbs, or consider green energy options.

If you experience resistance, you can have your fellow students, parents, or parishioners sign a friendly petition calling for greener practices. You might even suggest that your organization take a carbon-use inventory and create a green action plan (as suggested in the Introduction to this book). As you approach decision makers, emphasize that our real enemy is excess greenhouse gases, and our reason for fighting them is to benefit all humans on earth and our beloved future generations. Even religious organizations that are skeptical about global warming may respond to a more general environmental call to action, keeping in mind our role as the stewards of God's creation (see Step 49, Know the Green Side of God).

As a customer at your local coffee shop or favorite lunch spot, if you notice that recycling bins are absent, feel free to request them. If they are incorporating green practices that you like, let them know that, too. Keeping customers happy is important to retailers and restaurateurs, so it's very important to give them feedback on what they are doing that makes you want to continue patronizing them and what they aren't doing that makes you feel inclined to go elsewhere.

You may find a time when doing a sit-in, protest, or public boycott is called for. Having the freedom to disagree publicly with the practices of corporations and government is one of our greatest rights in America. When protesting, you may create some meaningful dialogues, as did the peaceful group of protestors who visited the home of Sir Mark Moody-Stuart, former Chairman of Royal Dutch shell in the documentary The Corporation. Granted that his response to their unannounced visit was unusual,

Moody-Stuart had an open dialogue with the protesters, and offered them tea and lunch on his lawn. As they talked, Moody-Stuart and the protesters discovered they shared similar environmental concerns, although they differed in their approaches to the solutions.

If public protests aren't your style, consider joining the Stop Global Warming Virtual March online at www.stopglobalwarming.org. At the time of the printing of this book, there are almost one million virtual marchers, which means that one out of every 300 people in the U.S. is interested enough in global warming to have found this particular website. Displaying tasteful eco-bumper stickers, license plate frames, and even clever T-shirt messages is another way to spread the word to people in your community. If you have a long commute in a big city, you could actually make hundreds of impressions every week without opening your mouth!

A great way to share your green enthusiasm with your community is to plan an Earth Day event, eco-party, or neighborhood tree planting. These events tend to be very fun, bonding experiences for participants of all ages who can work and play together to fight global warming.

To prepare for this step, arm yourself with knowledge by reviewing the EPA's website on climate change (www.epa.gov/climatechange) or their site especially for kids (www.epa.gov/climatechange/kids). The International Panel on Climate Change (IPCC), the group that won the 2007 Nobel Peace Prize along with Al Gore, offers very detailed scientific information about global warming on its website. Keep current on green issues by listening to the Green Living Radio Hour with David Steinman (www.webtalkradio.net) or by enjoying other green media. (See the Green Patriot website for a variety of options: www.greenpatriot.us/greenmedia.html.)

By raising your voice for the environment, you become a positive force for a green, global warming–free world.

Resources

- www.congress.org
- www.earthportal.org/forum
- www.epa.gov/climatechange
- www.epa.gov/climatechange/kids
- www.greenpatriot.us/green100.html
- www.greenpatriot.us/greenmedia.html
- www.gristmill.org
- www.senate.gov
- www.stopglobalwarming.org
- www.thecorporation.com
- www.thedailygreen.com
- www.vote-smart.org
- www.webtalkradio.net

STEP #37
Invest in
the Solution

There's an awful lot of truth in the adage, "money makes the world go 'round." The billions of buying decisions made by consumers worldwide can, in the aggregate, make or break our efforts to stop global warming. The good news is that as the issue of global warming grows in our collective consciousness, there are a growing number of opportunities to save and make money without the greenhouse side effect. If you are looking to invest your money wisely, this step will help you to grow your portfolio and shrink the peril of global warming.

As more consumers recognize the importance of our buying power in halting climate change, more of us are seeking environmentally responsible investment options. Such options include funds such as Green Century and Domini Social Investments (both from the Green Patriot Green 100 list), Pax World Mutual Funds, and Calvert that invest in companies they deem earth-friendly in terms of their products, processes, practices, and principles. These funds rigorously screen companies to ensure they are investing your money only in the greenest companies and also push companies in green directions through assertive advocacy work.

Rising demand for greener products unfortunately has also spawned impostors seeking to tap into the growing demand. While most so-called socially and environmentally responsible funds really will invest your money in

companies that are part of the global warming solution, it takes an informed and discerning consumer to sort through the expanding number and spectrum of green-investment choices.

The first step in your green-investing quest is to set your investment priorities. Assuming that your overarching goal is to make money while supporting significant work to cool the planet, you can choose key criteria and thresholds: what types of companies, products, and technologies the various green funds invest in; what changes the funds demand of current and prospective companies as a condition of their investment; and the like. For example, some green funds invest in "big-box" home improvement stores because they purchase more responsibly harvested lumber—but if you believe that such stores have a more negative than positive impact, then that fund may not be the one for you. Some funds push development of alternative energy more aggressively than others, and some are more hands-on when it comes to pushing change in corporate boardrooms. As hard as it can be to find the time and discipline, it can pay to read a fund's prospectus— including all the numbers and fine print.

When looking at a specific fund that claims to invest in global warming solutions, it's helpful to ask some very pointed questions: What are the fund's environmental priorities? What companies does the fund invest in, and why? What companies does the fund not invest in, and why not? What do the funds demand of companies that they currently invest in and of prospective companies? Does the fund—and the companies it invests your money in—walk the talk with the day-to-day business decisions and practices?

And this last question is certainly important as well: How much green will this green fund likely make for me?

As you wade through the rising tide of green-investment options, there are helpful resources available to you. For example, Co-Op America's online Guide to Socially and Environmentally Responsible Investing (www.coopamerica.org/socialinvesting), Social Investment Forum (www.socialinvest.org), and Social Funds (www.socialfunds.com) can guide you through options and choices for your own green investing. *Green Money Journal* (www.greenmoneyjournal.com) can help you "invest in bigger schools" of fish!

As corporations big and small begin to respond to the warming world, more of them are candidates for your environmentally and socially conscious investments. This is great news—but more options don't automatically make for easier choices! Use the resources listed here and you'll be on your way to investing in a better future for you and your world!

Resources

- www.calvert.com
- www.coopamerica.org/socialinvesting
- www.domini.com
- www.greencentury.com
- www.greenmoneyjournal.com
- www.greenpatriot.us
- www.paxworld.com
- www.socialfunds.com
- www.socialinvest.org

STEP #38
Support Green Businesses

We all know that money talks, but do we realize how loudly our collective shopping dollars shout, forcing companies to listen to our choices, and to attempt to understand our preferences? When we choose to support companies that make and market goods that reverse rather than advance global warming, we are exerting a powerful, positive influence on climate change. As corporations decide how goods are processed and distributed, their choices have been—and will continue to be—a tremendous contributing factor in the state of the global warming crisis.

Even the most powerful corporations in the world were made that way by consumers who decided to buy their products. This means that we, as consumers, are truly the most powerful force for change. All that is needed to turn the tide is a critical mass of consumers who buy greener, and we are already well on our way! Now that you know you're sitting in the driver's seat of our entire economy, use your consumer power to influence positive changes for the penguins, the polar bears, the people, and the planet as a whole.

According to the Lifestyles of Health and Sustainability (LOHAS) Forum, 35 million Americans today demand and support environmentally beneficial goods and services, with their total annual buying topping $208 billion. Although this is a big number, it's still only about 12 percent of Americans—a clear minority, but a rapidly growing demographic as well.

During the past several years—particularly after the release of *An Inconvenient Truth* and the resulting rise in public concern about global warming—more and more corporations are jumping on the green bandwagon. It has become an accepted fact in corporate-marketing groups that large companies catering to wide demographics must be seen as green-friendly or risk losing a significant percentage of their customers.

If you watched the green business news announcements at www.greenbiz.com in 2007, you would have noticed that virtually every day, another major corporation announced it was greening its practices, or a group of companies announced the formation of a new corporate alliance or coalition with a green mission such as sustainability and combating climate change.

The role of Corporate Social Responsibility (CSR) Director at a corporation is held by the person or group who assesses the overall impact of a company's practices on society. While CSR analysts became common in the 1970s, they are now taking a more prominent role and continue to be very environmentally focused, due, in great part, to demonstrated consumer demand.

Today's consumers are responding more and more to information about how companies are behaving in relation to what's best for people and the planet. Many consumers boycott products that they hear are detrimental to the environment. In turn more companies are promising to donate a portion of their profits to worthwhile causes and more companies are advertising on their packaging that they source only sustainable materials, use organic ingredients, don't conduct animal testing, or use free-range animals.

The Green Patriot Working Group has identified a list of 100 exceptional green companies called the Green

Patriot Green 100™ companies (see www.greenpatriot.us/green100.html). These companies were selected for their leadership in environmentally sustainable business practices. The list ranges from small, homegrown companies, such as Esperanza Apparel, to enormous multi-national corporations, such as Target and Nike, who have been chided as well as cherished when it comes to environmental performance. The Green Patriot Green 100 companies are not all practicing perfect carbon neutrality. The common denominator is that these companies have demonstrated impressive, real action and leadership in the quest to stop global warming.

Supporting these 100 companies—as well as others you know that are taking action to squelch global warming—will reward their green leadership and encourage other companies to follow suit. And every time you support green companies such as these, you can feel great knowing that you are helping to turn the marketplace green, which will in turn help save our earth from global warming.

One of the Green Patriot Green 100's companies, Co-Op America, also runs a terrific website that can help you to identify leading green companies in your neck of the woods. And another great Green 100 company—Greener World Media—provides a tremendous amount of valuable information daily on their websites GreenBiz, ClimateBiz, GreenBizLeaders, GreenerBuildings, GreenerComputing, and GreenerDesign (see Resources).

As more companies turn green, the Green Patriot Green 100 list will likely grow to the Green 200, the Green 500, and beyond. It's a good sign that change is already very visible in the marketplace, and as we continue to vote for a healthier world every time we shop, we are likely to see a much greater transformation in the immediate years to come.

Resources

- www.climatebiz.com
- www.coopamerica.org/pubs/greenpages
- www.greenbiz.com
- www.greenbizleaders.com
- www.greenerbuildings.com
- www.greenercomputing.com
- www.greenerdesign.com
- www.greenerworldmedia.com
- www.greenpatriot.us
- www.lohas.com

STEP #39
Buy Green Energy

When you flip on a light switch, you probably think of, well, light. But do you ever think about coal? The majority of U.S. residents get their electricity from coal-fired power plants, and these plants contribute 40 percent of America's carbon dioxide emissions. Being largely carbon itself, coal releases copious quantities of carbon dioxide when burned. So running just one 100-watt light bulb 12 hours a day for a year requires 357 pounds of coal and pumps about half a ton of carbon dioxide into the atmosphere.

Thankfully, more renewable energy options are available today than ever before, which means you can start now to wean yourself from fossil fuels (natural gas is another major energy source for electricity), and at the same time help to build a bigger and better green energy market that reaches far beyond your own home.

Wherever you live, chances are high that you can obtain emissions-free power, in the form of solar, wind, hydro (water), geothermal (underground), biomass (plant matter), or even methane (gas from landfills). Hydrogen fuel cells are being developed and may be a more mainstream option within a decade. And whatever form it takes, every kilowatt hour of renewable energy prevents a full pound of carbon dioxide from entering the atmosphere.

The easiest way to get started with green energy is to order it right from your utility company. Utility companies in 35 states offer green power pricing plans. For example,

the Sacramento Municipal Utility District in California offers its customers wind, solar, hydro, and even landfill gas energy for as little as $6 more each month. Although the customer's home won't actually be powered by wind power (for example), the amount of energy that they use will be generated somewhere in the shared electric grid by wind power, if they select this option.

See if your state is on the list by checking this U.S. Department of Energy website: www.eere.energy.gov/greenpower. Call your utility, visit their website, or check your last bill or statement to learn about their green energy offerings.

You can also buy a custom green energy system for your home or business from companies that purvey wind, solar, and geothermal power. In western New York, for example, there are almost two dozen companies that manufacture, sell, and/or install customized home or business wind, solar, or geothermal systems (see www.renew-ny.com). At findsolar.com, you can find companies in your corner of the country that can customize a solar system for you—from a solar hot water heater to the whole photovoltaic enchilada!

Federal and state governments offer various tax deductions or credits for purchase of home solar and other renewable energy systems. For details, see the website of the Directory of State Incentives for Renewables and Efficiency (www.dsireusa.org).

As equipment, installation, and maintenance costs for many green energy systems tend to be quite high, it's clear why more households didn't switch to solar or other green power decades ago. Even considering the savings on electricity bills, many systems don't pay for themselves for 20 years or more. Currently, solar and wind power combined account for less than 2 percent of electricity use

in the U.S., although this number is growing as more customers switch to green energy and invest in carbon offsetting.

As we wait for technology to advance and prices to go down, there are several lower priced options for homeowners to consider. You can save on your solar power purchase with "net metering," where energy generated at your home is not stored in a solar array but instead goes back to the shared electric grid, and you pay for any shortfall of energy from your system. On the flipside, if you generate more energy than you use, you receive a credit. Thanks to the Energy Policy Act of 2005, all public electric utilities in the U.S. are required to offer net metering to their customers on request.

Solar systems are also available for lease today by an innovative green company called Powur of Citizenre (www.powur.com). Citizenre makes it easy on those who cannot afford the up-front capital costs of green power. They install their solar equipment for free and charge you the same rates you would pay your existing power company. They also keep your current rates locked in for up to 25 years and perform all maintenance at no cost.

As a new green energy consumer, be sure you're getting the greenest energy at the lowest price. At the EPA's website (listed in Resources on the following page), you can check out the *Guide to Purchasing Green Power* and get familiar with the key criteria and critical questions to ask.

You'll find that going with green energy really is empowering—you'll make a big difference for the green energy market and the green movement, and you'll feel great about your contribution to solving the world's most pressing problem. The more we make green energy part or all of the energy we purchase, the more we move the mandate for a cooler planet!

Resources

- www.dsireusa.org
- www.eere.energy.gov/greenpower
- www.epa.gov/greenpower/locator/index.htm
- www.findsolar.com
- www.green-e.org
- www.powur.com

STEP #40
Do It Online

While many modern inventions have contributed to the growing problem of excess greenhouse gases in our atmosphere, modern technology can also help us to save trees and burn less fossil fuel as well. The Internet has been positive for humankind in so many ways, and it will be key to achieving our plan for carbon neutrality. We can do many of our tasks, errands, and information-gathering expeditions online to save trees, gas, money, and time.

Think of all the gas we save by logging on instead of driving. Millions of us are taking advantage of the convenience the Internet offers. The recent advent of the Internet makes it easy for us to simplify our lives and reduce our reliance on vehicles by using our computers to shop, send a gift, pay bills, or book a trip, without ever leaving home! (See Step 25, Green Your Office, for tips on minimizing the energy used by your computer.)

Paying bills and banking online has become a reality that many of us enjoy. We can pay just about every bill we have, from utilities to credit cards and cable bills, online. This eliminates paper, stamps, and the drive to the post office to mail in our payment.

Most employers offer direct deposit too, so you can have your paycheck automatically deposited into your bank account and save your car and yourself an extra trip. Many banks even offer incentives for those opting for paper-saving direct deposits. Additional time can be saved by

setting up auto bill pay through your bank accounts, which allows for bills to be paid automatically—you specify the amount and date. All you have to do is remember to deduct it from your account!

Looking up phone numbers and addresses is also easy to do online and has made paper phone books virtually obsolete. Several online "phone books" exist, so you can quickly find a business or person. Recycle those bulky paper- and oil-consuming phone book dinosaurs and request to stop their delivery. (See Resources.)

You can also save portions of rainforest by re-evaluating the catalogs, magazines, and newspapers that arrive at your home. You can read many of these online, which saves paper as well as delivery-transportation and subscription costs. For those favorite magazines you just have to hold in your hands, be sure to recycle them or pass them on to a friend after you've finished reading them.

Most of us would be happy if we stopped receiving junk mail, and the rainforests would be much better off. A simple phone call or short note can keep unwanted postal ads from clogging your mailbox. Write to Mail Preference Service, Direct Marketing Association, 6 East 43rd St., NY, NY 10017, and ask them to remove your name from mailing lists, or contact the Stop Junk Mail Association at (800) 827-5549. The Simple Living Network also offers a booklet, "Stop Junk Mail Forever," available by calling (800) 318-5725.

One of the most fun things to do online is to shop. The plethora of online retailers makes it simple to do comparison shopping, thereby eliminating the need to drive from store to store and saving you gas and time.

Do keep in mind, however, that buying online from local merchants rather than those far away is the greenest way to go. Having your product shipped from a closer

location cuts down on transportation-related costs, including CO_2 emissions. In addition, request ground shipments rather than air to further reduce emissions generated by your purchase. If you're buying a gift, you can have it sent directly to the recipient, so you won't even have to stand in line at the post office. Most companies will gift wrap your purchase too.

For some excellent online consumer guides to eco-friendly products, check out the Green Patriot's Green Consumer Product Guide, Co-Op National Green Pages, or EcoMall to find the greenest products and to search for providers of those products that are in your vicinity.

Last and certainly not least, telecommuting (as discussed in Step 25, Green Your Office) one or more days per week is a tremendously efficient use of the Internet, especially if an employee works far away from their home.

Indeed, converting many of your errands to computer-based instead of car-based jobs can go a long way toward cooling the planet!

Resources

- www.co.clark.wa.us/recycle/reduction/junk.html
- www.commoncraft.com/how-stop-receiving-phone-books-and-yellow-pages
- www.coopamerica.org/pubs/greenpages
- www.ecomall.com/biz
- www.greenpatriot.us/greenconsumer.html
- www.thegoodhuman.com/2007/07/09/please-stopdelivering-the-phone-book-to-my-house

STEP #41
Send an E-mail a Day

While paper-free electronic mail may be the greatest invention to ever happen to the tree, it is also becoming an increasingly potent weapon in the battle against global warming. E-mail transfers information at the speed of electricity, which is very convenient when your time is limited and the issue is urgent. Today's e-mail—sent and received through all kinds of stationary and portable devices—is the primary form of communication for government and businesses.

It's actually quite easy to send a daily e-mail to government or businesses, urging action against global warming. Many environmental organizations, such as Environmental Defense or the National Resources Defense Council make it simple to be an effective advocate by periodically sending an e-mail when current environmentally sensitive issues are up for a vote in Congress or in the marketplace. Simply sign up on their website to receive these notifications.

If you are interested in responding to a particular issue, these websites will quickly walk you through sending a pre-written e-mail message to the head of a corporation or select group of your government representatives. These organizations have done all of the research for you, and they know who your particular representatives are, according to your zip code. All you have to do is follow some simple instructions, and presto! There goes an e-mail in your name

to someone who could and should do something about global warming.

And it's possible that your e-mail could, with one click of a "Send" button, reach hundreds of government and business leaders who increasingly see e-mail as an important means of feedback from their constituents and customers. Even if you don't have detailed knowledge of the science and policy related to global warming, you can make an impact without ever leaving your virtual desktop.

If you're a more independent type and prefer to author your own correspondence, it's also easy to send a daily e-mail to one of the people or organizations you think needs to act on an issue. You can start with what you personally feel most passionate about: You might want to ask your state representative to support higher mpg and lower emissions standards for vehicles, or you may feel behooved to urge a local supermarket chain's management to buy green power and fewer products from overseas that could be procured locally.

Virtually every medium- to large-sized corporation today has a website with a "Contact Us" page that enables customers to e-mail suggestions, questions, and feedback. Most local, state, and federal representatives also have websites and e-mail addresses, and some feature user-friendly feedback forms on their websites.

At www.congress.org, you can find out who your national as well as state representatives are, and you can write your e-mail to them right from that site! You can also use Internet search engines such as Yahoo and Google to find e-mail addresses for your local/municipal officials, corporate executives, non-profit, or agency staff, and just about anyone else you want to reach about global warming. When writing your e-mails, consider these guidelines, most

of which are found at www.dosomething.org/
tipsheets/energy_conservation_politics:

- When writing a corporation, begin by
 letting them know that you are a customer (if
 this is true). E-mails from loyal customers have the
 most clout with intelligent companies. If you haven't
 purchased their products in the past but are
 considering a large purchase (such as a car), let them
 know this. Customers with the financial means to
 buy and who are shopping in their market are
 extremely important to corporations.
- When writing an elected official, find out if there are
 bills or resolutions currently being discussed that
 relate to your concerns. (Visit www.senate.gov and
 thomas.loc.gov.) You may also read about a bill or
 resolution on the floor or in the process of being
 written up. (Bills/resolutions are usually titled by
 "HR" or "HB" in the House and "S." in the Senate,
 followed by a few numbers.) If so, reference it in
 your letter, and state whether you want your
 representative to support or oppose it.
- Be polite. Don't be overly harsh or use profanity.
 Not only is it rude, but likely you won't be taken
 seriously. If you also offer a compliment for
 something else (i.e., "I have enjoyed using your
 product for 15 years"), you will come across like a
 reasonable person and the main point of your letter
 will have more impact.
- Be concise. Even if you are passionate enough to
 write a short essay on the subject, don't. Get to the
 point in a few paragraphs. Project Vote Smart
 (www.vote-smart.org/index.htm) is a great resource
 for learning how your elected officials are voting on
 environmental issues, allowing you to target your
 writing campaigns accordingly.

Even if you don't own a computer or have much knowledge of e-mail and the internet, you can send e-mails from most public libraries that offer free computer access and assistance. Free e-mail accounts (such as gmail at www.gmail.com) are easy to acquire—anyone can have one within minutes of logging on to a computer.

It's great for our planet that e-mail offers tree-less, car-less correspondence! And it's fortunate that most government officials and corporate executives count e-mails and take them very seriously. Make use of this simple, yet powerful tool for change!

Resources

- www.action.lcv.org/lcv/home.html
- www.actionnetwork.org
- www.congress.org
- www.dosomething.org/tipsheets/ energy_conservation_politics
- www.ecomall.com/activism/activism.htm
- www.environmentaldefense.org/actioncenter.cfm
- www.nrdc.org/action
- www.saveourenvironment.org
- www.senate.gov
- www.vote-smart.org

STEP #42

Run Your Car on Vegetable Oil

For better or worse, our society is dependent on motor vehicles. For most of us, our daily lives are filled with vehicle trips, for just about every out-of-home need and activity we undertake. As the exhaust from our vehicles is rich with carbon dioxide, this means that trips to school, work, the grocery store, and the beach contribute to global warming. The good news is that there are fast-developing new alternatives for meeting our transportation needs without imperiling polar bears or jeopardizing our future.

Running diesel vehicles on biodiesel fuel has become an accessible option for more households and businesses that don't want melting glaciers and choking fumes to be a side effect of their transportation choice. Biodiesel is made primarily from vegetable oil, such as soybean oil. In its purest form it is petroleum-free, but it is commonly mixed with regular petroleum diesel fuel to create various lower cost and more engine-compatible biodiesel blends.

Most commonly available today is "B20," a blend of 20 percent biodiesel and 80 percent regular petroleum diesel. B100—or pure biodiesel—is sparsely available today, and is twice as expensive now as petroleum diesel (30-40 percent more than B20).

Vegetable oil becomes biodiesel when a chemical transformation causes the glycerin in the vegetable oil to detach from the *methyl esters*, or the remaining content we call biodiesel.

You may have seen news stories about do-it-yourself fuel makers who scoop up vats of used cooking oil from burger joints, return to their garages, and concoct their own biofuel for their old, modified diesel cars. However, the National Biodiesel Board discourages buying homemade biodiesel because it likely fails to meet the strict product specifications and safety standards set by government regulatory agencies. These standards have been set to protect the air, engines and vehicle parts, and you! The National Biodiesel Board suggests buying biodiesel from certified makers and distributors.

For those who don't have diesel vehicles, there is ethanol, a fuel made from corn, that is rapidly becoming more available across the country. However, research shows that biodiesel cuts global warming emissions over three times more than ethanol, when the production as well as the combustion of the fuel is considered. There is growing concern that the energy costs of producing ethanol will make ethanol use ultimately a zero-sum game for the environment.

So how does biodiesel benefit the environment? Pure biodiesel cuts carbon dioxide emissions by three quarters. Even the more commonly used B20 reduces the carcinogenic particulate matter and carbon dioxide loads into the atmosphere. This reduction includes pollution prevented by the cleaner overall life cycle of the fuel's production. Pure biodiesel is renewable and quickly biodegradable, and reduces our dependence on long-distance petroleum products that, ironically, have to be transported using copious quantities of the same fuel!

Pure biodiesel is also non-toxic and safer, as its flash point—the lowest temperature at which it will ignite when mixed with air—is higher than that of petroleum diesel. There is one major catch, however: Biodiesel has been

shown to produce 10 percent more nitrous oxide than conventional fuel, and this is the emission that causes smog. This is a reminder that the best transportation choices for the environment are the ones that use no fuel at all!

While biodiesel's availability and use are expanding quickly, the cost of this fuel may render it a non-option for you right now. The good news is that the federal government now requires all petroleum diesel fuel to be cleaner (by way of lower sulfur content); and there are new technologies to retrofit diesel engines in ways that reduce dirty, sooty particulate emissions from traditional petroleum diesel by over 90 percent.

Thanks to biofuel development, the diesel vehicles we used to associate with their smelly, smoke-belching ways can now help to halt global warming. Earth Biofuels is working to reverse the reputation of diesel by naming their BioWillie brand biodiesel, after legendary country performer Willie Nelson.

You too can help the humble soybean become a key part of the global warming solution. Even your favorite diner or donut shop can be a part of the biofuel solution by providing biodiesel companies with their used cooking oil. Companies like Standard Biodiesel in western Washington State make it easy for restaurants to recycle their used oil— and get paid for their participation in the clean energy revolution!

Resources

- www.Biodieselamerica.org
- www.biodiesel.org
- www.biowillieusa.com
- www.standardbiodiesel.com

STEP #43

Say Yes to the U.S.

With Asia supplying billions upon billions of goods sold in the United States, the number of cargo containers offloaded at California's Port of Long Beach has tripled in a decade. Traffic jams of leviathan, cargo ships—some carrying over 10,000 full tractor-trailer-containers—are not uncommon in Long Beach.

Inside these ships' containers are products your family uses every day: jeans, cell phones, toasters, teddy bears, paper clips, bicycles, basketballs, and much, much more. Even non-exotic daily foods such as apples and soybeans come to us routinely by giant ships. Just one of these ships can burn 400,000 pounds of diesel fuel per day (of their 30,000,000-pound capacity), spewing out countless tons of carbon dioxide and carcinogenic particulate pollution. Because the emissions of these ships are not regulated as strictly as those of land vehicles, one container ship coming into the harbor at Long Beach can produce emissions equivalent to over a third of a million modern passenger cars.

With so much global warming riding on the everyday products we use, how can we cut the climate change associated with our goods?

Buying products made in the United States is a good start. The more local you can buy, the better. However, there's an unavoidable challenge in trying to buy local these days: given the global economy, an "American-made" product may be comprised of components from all over

the world. It's even common today to have a product made from materials from one country, assembled in another, and shipped back for sale to the country where the materials originated.

So how can we truly be Green Patriot consumers and make sure we are buying American-made products and buying from our state, region, and community? You must do some research to ensure that your purchases are serving to slow global warming. As information about the source of materials and parts in goods isn't always easy to come by, becoming informed about your buying decisions does take some legwork.

Labels on products can provide information, but most often they only tell you where the product was manufactured, rather than the sources of its component parts and materials. However, armed with your phone, computer, and pen, you can get detailed information about the products you are considering: about where the materials come from, where and how the products are manufactured, and how they are transported to stores and customers. The best merchants will be able to provide this kind of information about their products; they can also direct you to the manufacturers for more information (or even contact them for you). If the stores aren't shedding enough light on the makeup and life cycle of the product, use the Internet to search for customer service and product hotline phone numbers—or even the numbers for corporate headquarters.

Making your desire for this detailed product life cycle information known to manufacturers and retailers can have the effect of pushing them to proactively provide this information to all consumers, as they see that providing such information is key to keeping and attracting more eco-conscious customers.

If you're lucky enough to have a local farmers' market or community-supported agriculture farm in your community, you can buy super-local, and get the best and most direct information about the groceries you buy. (See Step 6 for more information on Buying Locally Grown Food.)

Sometimes these buying decisions can be befuddling. For example, is it better to buy non-organic apple juice made from apples grown in your region or organic juice shipped from Mexico? These cost-benefit analyses aren't easy, but thankfully, there are organizations like Co-Op America and the Union of Concerned Scientists (UCSUSA) that can help you out. The UCSUSA book *Consumer's Guide to Effective Environmental Choices* can help with conundrums like this one and help to get your environmental priorities straight.

There's no shielding the fact that being a conscientious shopper for a cooler planet takes some effort. But there are organizations and resources at the ready to help make this quest smoother.

Resources

- www.coopamerica.org
- www.coopamerica.org/pubs/greenpages
- www.eco-labels.org
- www.newdream.org
- www.ucsusa.org

STEP #44
Plant a Tree

Trees are the unsung heroes of our ecology. They provide shelter, shade, and food for other living things. They purify air and water. They majestically beautify all corners of the world. They humbly provide for much of human society and economy. And what's more, they continuously convert carbon dioxide into oxygen, making them heroes in the quest to halt global warming.

But many of the same human actions that cause global warming are also degrading the world's forests. This is a double whammy because trees absorb carbon while alive, but emit it when they die, so trees that are felled not only stop capturing carbon—they also give it off. Worldwide, deforestation is responsible for one-fifth of carbon dioxide releases into the atmosphere.

The Union of Concerned Scientists (UCSUSA) reports that in the United States, carbon capture by forests declined 20 percent between 1990 and 2001, primarily because of land clearing for development and destructive forestry practices. Unnatural, catastrophic forest fires—possibly exacerbated by global warming–induced drought—are also responsible. UCSUSA believes, though, that the carbon-absorbing potential within American forests, grasslands, and farmland can offset even more than the 20 to 45 percent of the annual carbon dioxide emissions they currently capture, if we reverse these practices.

Of course, conservation is the best sequestration, meaning that we absolutely need to reduce our emission of

greenhouse gases. The current load clearly overwhelms the capturing ability of even our noble forests. But while we get our conservation act together (by doing the other 49 things suggested in this book!), we can offset carbon dioxide significantly by planting trees, and by ensuring that the trees currently standing stay that way, green and growing (older, more mature forests sequester carbon better than younger ones).

Planting a tree is simple and wonderful. It nourishes nature and also your soul. In 1953, Jean Giono wrote *The Man Who Planted Trees*, a short story about a shepherd, Elzear Bouffier, who restored a degraded mountain valley in the Alps by patiently planting thousands upon thousands of acorns, one at a time, over decades. His work resulted in a robust forest, enjoyed by animals and humans alike (although none of the people knew the source of the verdant valley). While Giono's story is fiction, there are real life Elzears at work today—you can be one, too! Kenyan Nobel Peace Prize winner Wangari Matthai started the Green Belt Movement in 1977, which organized impoverished rural women to plant trees in response to the scourge of deforestation. These remarkable women have since planted 30 million trees.

Los Angeles–area residents can take part in Mayor Antonio Villaraigosa's Million Tree Initiative, which began in 2006. Organized by TreePeople and the Los Angeles Department of Recreation, the tree-planting venture counts on volunteers to plant trees in the metropolitan community. TreePeople successfully steered a similar movement to plant a million trees before the 1984 Summer Olympics in Los Angeles. To volunteer, contact volunteer@treepeople.org.

Planting trees can be a solitary, family, or large group activity, organized or impromptu.

The national Arbor Day Foundation has great tips on its website (see Resources on the following page) about which trees are best for your area; local garden centers, cooperative extension offices, and forestry departments are also excellent sources of information and may even provide seedlings!

Tree planting helps combat global warming. It adds beauty to an area, aids in community-building, and can serve as a memorial for honoring someone special. A truly green gift, trees provide protection from the sun and wind and are homes for birds and other wildlife.

You'll love planting trees yourself, but there are also ways to support tree planting and carbon capture around the world without wielding a spade. Several organizations are running tree-planting campaigns. Getting involved has never been easier!

Trees for the Future works with local communities to restore degraded lands by planting trees in Africa, Asia, and Latin America. Through the website, you can commission tree plantings just about anywhere and for any occasion. Through American Forests' Global ReLeaf initiative, you can support the planting of trees throughout the United States. Via the Arbor Day Foundation, you can support tree planting and also get key tips on planting and caring for trees yourself. At www.climatecare.org, you can offset carbon emissions through funding an array of sequestration projects, including rainforest reforestation. And you can even plant trees when you take a plane trip—through Travelocity. Conservation Fund's "Go Zero" carbon-offset initiative for travelers plants native trees to offset carbon resulting from travel.

Trees aim high—let's learn from their example! You can stand tall in your carbon-positive quest by organizing and implementing a tree-planting project of your own.

Resources

- www.americanforests.org
- www.arborday.org
- www.arborday.org/trees/righttreeandplace
- www.conservationfund.org
- www.milliontreesla.org
- www.seedtree.org
- www.travelocity.com
- www.treepeople.org
- www.treesftf.org
- www.ucsusa.org/global_warming/solutions

STEP #45
Take a
Local Hike

Recreation is important for the body, mind, and soul. But is it always good for the planet? Modern-day leisure activities are becoming more electricity- and gear-intensive: jet-skis and Boston Whalers ply our waters; climbers scale cliffs with the aid of SUVs big enough to fit all of their gear; and people plunge through wilderness year-round on all-terrain vehicles and snowmobiles.

Now we're not suggesting you go off-roading in your 2-door sedan; thankfully, there is a cornucopia of meaningful and rejuvenating recreation choices that are more climate conscious.

For example, taking a hike can be beautiful in its simplicity, yet profound in many ways. Hikes can recharge and strengthen your health, inspire your knowledge and love of ecology, and be blissfully low-impact too. Cycling, swimming, and kayaking can also be high on health benefits and low on environmental costs.

Your walk in the woods can be carbon-free or carbon neutral, depending on how you do it. If your usual mile-long hike begins only after a 50-mile drive, you can likely find a trail closer to home. Even better, you can hike or bike to the trail! If there aren't wilderness trails within walking or cycling distance, you might find that a "front country" hike in or near your neighborhood can be filled with flora and fauna, and some new learning or appreciation about your community, nature, and the interface between the two.

You'll likely be amazed at what you find when you explore your backyard or neighborhood on foot—looking up in trees and under logs all along the way!

If you do drive to your hike, there are ways to reduce or offset its global warming impact. Couple your trip to the trail with efficient errands and other to-dos that can eliminate another car trip, or bring others along with you who might otherwise take their own car out for recreation. You can also turn your walk or other recreational outing into a service project that aids Mother Nature such as tree planting, trail restoration, erosion control, environmental education, or coastal cleanup. (To find out about organized restoration and clean-up activities, check with your local Sierra Club or other local groups.)

When preparing for your hike, plan to gear up in ways and with materials that help rather than hinder your quest for a low-carbon experience. For example, you can bring tap water in a reusable bottle rather than bottled water in disposable plastic; you can also tote locally produced snacks and drinks with minimal packaging.

Organized hikes with outdoor clubs, environmental groups, land trusts, and the like can be enlightening as well as efficient, led by expert guides and arranged with carpools.

Leave No Trace is a national organization dedicated to teaching users of the great outdoors to do so with care. Their tag line—"from your backyard to backcountry"— means that there's a need to consciously curb your impact everywhere you go to enjoy the great outdoors.

There is a chance your local bookstore will have an outdoors section that stocks hiking guides with local gems that you don't already know about. Many of these guides will also be online. Whether you want the well-worn path or prefer to go off the beaten one, there's surely an array of ambling options not too far from your front door.

Several steps in this book mention that connecting with nature is key to being the best battler against global warming. And as walking is frequently touted as the best exercise for all-around health, a simple hike can really be a win-win for people and the planet.

Resources

- www.localhikes.com
- www.mysigg.com
- www.lnt.org
- www.sierraclub.org

STEP #46
Recycle Your Shoes

If you want to really walk the talk and be green from head to toe, treading on green shoes is the way to go.

A sizeable number of eco-conscious companies are turning out shoes made from renewable, recyclable, and recycled materials like jute, organic cotton, latex, and cork.

Simple Shoes is a small company striving to make its shoes 100 percent sustainable. From its source materials, including organic cotton, recycled plastic bottles, and recycled car tires, to its manufacturing, Simple believes, "How we make our shoes is just as important as why." Simple's Green Toes, ecoSNEAKS, and Green Piggies are fashionable footwear lines reflecting their maker's environmental edge. "It's not only possible to reduce the ecological footprint left by shoes…it's our duty to do so," says Simple.

Nike also deserves kudos for stepping up to answer the call of duty, working for 14 years to eliminate a super greenhouse gas called sulfur hexafluoride, or SF6, from the cushioning air pockets on its famous Nike Air sneakers. In 1997, Nike Air footwear was responsible for emissions equal to that produced by one million cars. Although there was no law against using the harmful gas, Nike charged its design team with the task of finding an alternative method for making the air pockets, eventually creating the SF6-free Air Max 360.

Considered is the name for Nike's new line of climate-neutral shoes, developed in response to consumer demand.

Nike also collects used athletic shoes and turns them into sports surfaces ranging from tennis courts to baseball fields to tracks. Since this program began in 1993, they have donated sports surfaces to 150 schools, parks, and recreation centers in underprivileged areas, thus recycling, reusing, and reducing for a good cause.

To contribute to the cause, drop your sneakers at a Nike drop-off location (see Resources), or ship them directly to the Nike Recycling Center, c/o NikeGO Places, 26755 SW 95th, Wilsonville, OR 97070.

Recycling old materials, many from local sources and turning them into shoes sets Terra Plana a step above its competitors. Its Worn Again line, in collaboration with Anti Apathy, features shoes made from recycled car seats, jeans, and prison blankets! Other lines are made with recycled Pakistani quilts, vegetable-tanned leathers, and recycled rubber.

The well-known environmentally conscious company, Patagonia, recently released more than 30 new shoe styles adhering to its principle of the "best product causing the least amount of harm." Wearing these shoes made from recycled and natural materials from latex to hemp, you'll enjoy durability while being environmentally heeled as well.

Reusing has been taken to new heights on eBay where you can find more than 100,000 new and used shoes for sale, usually at a sizeable discount from store prices. Finding a few pairs to fit your feet should be a walk in the park.

Donating your gently used shoes to others in need is easy too: Just send them to one of Soles4Souls' warehouses. Soles4Souls, Inc., 315 Airport Road, Roanoke, AL 36274; or Soles4Souls, Inc., Foreign Trade Zone #89, 6620 Escondido Street, Las Vegas, Nevada 89119.

Hoof it over to your local shoe store to check out these other green shoes:

Charmoné is an Italian company that creates "killer heels" from earth-friendly, sustainable materials. Taking it a step further, the company donates 5 percent of its profits to eco-organizations.

Veja works with small producers in Brazil to produce shoes in a socially and environmentally conscious manner. Made with fair trade cotton, latex, rubber, and leather under sustainable conditions, Veja's shoes feel good on your soles and in your soul.

Whatever green shoes you choose, you can feel good that you are avoiding the creation of greenhouse gas emissions each time you avoid buying a brand new pair of non-recycled shoes.

Resources

- www.charmoneshoes.com
- www.nike.com/nikebiz/nikego/action_donate.jsp
- www.simpleshoes.com
- www.soles4souls.org
- www.terraplana.com
- www.veja.fr

STEP #47
Green Your Parties

All work and no play do not a happy Green Patriot make. With all of our hard work saving the earth from global warming, let's remember to take time to celebrate—greenly, of course!

With a few simple adjustments, we can turn our celebrations, from birthday bashes to baby showers, into eco-friendly fiestas—a step which raises awareness about global warming while keeping the good times rolling.

Check out these easy ways to add green to your parties:

Balloons. Believe it or not, your choice of balloons can affect global warming! Opting for latex rather than mylar balloons helps our environment. Balloons made from latex—a naturally derived rubber which is extracted without harming the rubber tree—are 100 percent biodegradable and break down as quickly as an oak leaf in similar conditions. Mylar, made from petroleum-derived polyester, takes hundreds of years to biodegrade. Harvesting latex has the added benefit of preserving tropical rainforest rubber trees (and we know more rainforests mean less CO_2 in our environment), according to balloonsgalorelansing.com.

Cakes. Organic, healthier cakes and goodies serve our bodies as well as our environment. Foods grown organically nourish the soil rather than saturating it with harmful pesticides and chemical fertilizers (the manufacturing of which contribute to greenhouse gases). Organic soils actually absorb greater amounts of carbon from the

atmosphere than soil containing pesticides and chemical fertilizers (see Step 5, Buy Organic Foods). When your party guests comment on how scrumptious the cake tastes, you can let them in on the benefits of organic foods. You can buy delicious organic cake mixes from goodbaker.com, at health food stores like Whole Foods Market and Trader Joe's, and at some mainstream grocery stores too.

Candles. Burn beeswax candles rather than the conventional kind and fire up the environmental conversation. Enlighten your guests about the benefits of beeswax, a 100 percent natural, renewable resource that actually improves air quality when lit, as it releases negative ions that remove pollutants and allergens from our air. In contrast, candles made from paraffin (a petroleum byproduct) pollute the air with unhealthy, black soot. We're told by idealbite.com that for every 10,000 people who choose "beeswax birthday candles instead of conventional, petroleum-based ones, we'll avert the weight of 4,000 birthday cakes in oil byproducts." For beeswax candles, visit www.bigdipperwaxworks.com.

Party Favors. Give green goody bags made from cloth or recycled paper and filled with earth-friendly treats to send your eco-message home with guests. Consider wooden toys with no packaging, art supplies, seed packets, or small plants like flowers or herbs, instead of made-in-China plastic throwaways (virtually all plastics are petroleum-derived). Or invite guests to make an eco-friendly craft to take home as a parting gift.

Plates, Cups, & Utensils. Eat and drink from reusable or biodegradable plates and cups instead of plastic disposables. Eco-Products and Plum Party offer compostable and biodegradable items made from earth-friendly materials including bagasse (sugarcane pulp),

recycled paper, cornstarch, and vegetable starch. Composting these materials reduces trash from carbon and methane-generating landfills.

Gifts. Designing your party theme around a good cause encourages creative gift-giving that reduces waste and greenhouse gases in our atmosphere. *The Green Guide* tells the story of a very successful puppy-themed birthday party where attendees were asked for donations or items for a local animal shelter in lieu of traditional gifts, and the shelter brought puppies for the kids to play with for the afternoon. Suggest children bring slightly used toys as gifts that will be fresh and interesting in a new home. Remember, every time we avert the production of a new toy, we also reduce carbon emissions.

Adults who already have all they need may want to request that guests donate to a specific cause in lieu of bringing presents. The collective donation might go toward the symbolic adoption of a wild animal such as a jaguar or an Irrawaddy dolphin from the World Wildlife Fund (see Step 22, Adopt a Panda) or toward the purchase of a farm animal, such as a llama or goat, from Heifer International (a group that provides animals and sustainable development training to financially struggling populations around the world).

At the conclusion of every cause-themed party, the group will have created something good for the world, instead of having purchased unwanted or frivolous gifts that add to the carbon emissions count. By requesting alternative gifting options, it also means your gifts won't be plastic or shipped from China. (See also Step 26, Give Green Gifts.)

Baby showers and weddings can also be green. Let guests know in the invitation that it is an "eco-friendly" event, and they will be more inclined to purchase accordingly.

Games. Games such as charades, musical chairs, and treasure hunts provide fun and generate zero waste. When planning games needing paper, conserve by using scrap paper, writing on both sides, and cutting paper into smaller pieces. In his book *Simply Green Parties*, Danny Seo suggests a method for creating eco-pinatas, as well as many other green party decorating tips.

Other fun carbon neutral activities like making crafts out of recycled materials or constructing edible creations such as gingerbread houses or mini personal pizzas will delight and entertain.

Confetti. If your party plans include confetti, Ecofetti, available at ecoparti.com is completely biodegradable and water soluble, leaving you with no landfill-cluttering mess to clean up.

Decorations. Use flowers to add color rather than wasteful paper streamers that require trees and carbon emissions to produce. Beeswax candles in patterned crystal dishes also add magic to an evening party. By breaking the disposable decorations habit, your decorations will often look a lot classier, and they may even double as party favors, helping you save money and the planet.

Resources

- www.balloonsgalorelansing.com.
- www.bigdipperwaxworks.com.
- www.ecoparti.com
- www.ecoproducts.com
- www.goodbaker.com
- www.idealbite.com
- www.plumparty.com
- www.thegreenguide.com

STEP #48
Buy Carbon
Offsets

As humans, we can't help but exhale carbon dioxide every time we breathe. But we can reduce the carbon dioxide we emit through everyday activities such as eating, driving, flying, staying cool and warm, typing an e-mail, and reading under a light. Even the greenest of us are still creating excess carbon dioxide emissions in a variety of ways. Fortunately, today there are many companies who will help us to counteract our carbon dioxide emissions by supporting an array of carbon-crushing green initiatives around the world, such as wind and solar energy development and tree planting.

Being "carbon neutral" is getting very trendy—the *New Oxford American Dictionary* even proclaimed "carbon neutral" as its Word of the Year for 2006. Online airline reservation sites now offer the chance to offset the carbon emissions of your plane trip with just a couple clicks and a few dollars. Al Gore's documentary *An Inconvenient Truth* worked to offset all the carbon dioxide emissions generated through its production. Companies like Google, HSBC Bank, and Ben & Jerry's Ice Cream are proclaiming with much fanfare their efforts to become carbon neutral. Even the famous Dave Matthews Band strives to offset the carbon emissions of its rock and roll.

Scientists have developed a number of projects in which carbon dioxide can be absorbed, or sequestered, in order to keep it from adding to the greenhouse effect. For example,

they plant trees and other plants that can absorb carbon dioxide prodigiously.

Technologies that capture methane gas (20 times more potent as a global warming gas than carbon dioxide) from decomposing landfill garbage are being applied coast to coast. And then there are the changes that prevent the emission of carbon dioxide altogether: switching to solar and wind energy, solar-powered electric and fuel cell vehicles, and the like.

You can support these carbon minimization and elimination activities today and reduce or neutralize your carbon footprint when you buy what are known as "carbon offsets." For example, through Sustainable Travel International, a $110 contribution to certified wind power projects across the United States will offset the seven tons of carbon dioxide generated by flying your family of four from New York to Los Angeles and back.

Carbon offsetting has grown tremendously since the release of *An Inconvenient Truth* in 2006 and has attracted some controversy. Supporters point out that carbon offsetting builds awareness and a sense of responsibility for an individual's carbon footprint. Dollars spent on carbon-offsetting projects create markets for developing new green technologies and projects that can have a significant impact on reducing and eliminating carbon emissions. For example, in 2006, the National Football League bought renewable wind energy to offset the 58 tons of carbon dioxide produced during a game in St. Louis. This large purchase of wind energy created substantial revenues for future wind power generation, research, and development.

However, critics say that buying offsets alleviates guilt without encouraging people to change their high-carbon lifestyles. They argue that some offsets don't actually produce enough quantity and quality of carbon

sequestration. This may be a good reason for consumers to demand more independent audits, but the argument that carbon offsets aren't doing as much good as they should can easily be put into perspective—several years ago, virtually no one was making carbon offsets, and there was a lot less capital to help grow these promising new green energy markets and carbon neutralizing activities.

Buying carbon offsets makes a difference, even if you don't offset in exact proportion to the carbon dioxide you produce. When you decide where to purchase offsets, you should heed the same "buyer beware" instincts that you use when shopping for any product. Following these suggestions will help you separate the best companies from the rest:

- Be sure the organization or company offering offsets gives you specific details about the offsetting activities your dollars will support.
- Check for scientific evidence that shows those activities sequester or prevent carbon dioxide or methane emissions.
- Look for endorsements from key oversight and certification organizations such as the Center for Resource Solutions.

Green-e is currently developing a certification standard for carbon offset providers. As more people jump on the bandwagon to strive for carbon neutrality, we are bound to see more consumer audit and review resources to help us sort through the rapidly growing business of carbon offsets. In the meantime, you can feel good about buying offsets for yourself or as a gift for loved ones, knowing that each offset purchased is a gift to future generations as well.

Resources

- www.carbonfund.org
- www.carbonneutral.com
- www.cleanair-coolplanet.org
- www.cleanair-coolplanet.org/consumersguidetocarbonoffsets.pdf
- www.davidsuzuki.org/climate_change/what_you_can_do/carbon_neutral.asp
- www.fightglobalwarming.com
- www.green-e.org/getcert_ghg_intro.shtml
- www.greenmountainenergy.com/carbon_offsets.shtml
- www.my-climate.com
- www.nativeenergy.com
- www.safeclimate.net
- www.terrapass.com

STEP #49
Know the Green Side of God

It can be helpful to look at our quest to defeat global warming from a spiritual perspective. Humankind shares a universal love and respect for nature. Therefore, our efforts to do what's right for the planet unite us with people of all religions, races, cultures, ages, political parties, and professions. And each green step we take spreads goodwill by benefiting all of the earth's present and future inhabitants, making us feel great about ourselves, and aligning us with our highest values.

Remember that nature is often what makes us feel close to God, even at times when nothing else will. Walking along a beach, watching powerful waves crash against the seashore, or standing amidst a majestic forest can evoke a connection to the divine, however we define it for ourselves. This is also where we often find peace and emotional healing.

Even those who don't believe in God per se often find a connection to spirituality through their interactions with nature. Remembering how close nature is to the core of our being is helpful in our journey to save the earth. If you become discouraged in your efforts, go out into nature to get re-inspired!

Virtually every established religion holds that humans have been given stewardship over the natural world and must care for and protect all living creatures. In these days we find that world religions are striving to apply the green dictates of their faiths to today's pressing environmental challenges.

In 2006, 86 Christian leaders established the Evangelical Climate Initiative, as a statement of recognition of human-induced climate change and to advocate action on environmental issues. Reverend Richard Cizik, the National Association of Evangelicals' Vice President for Govermental Affairs, has coined the increasingly popular term "creation care" for environmentalism motivated by Biblical principles.

In 2002, the Evangelical Environmental Network and Creation Care magazine launched its "What Would Jesus Drive?" campaign to emphasize the connection between key Christian tenets and how our transportation choices relate to global warming.

In 2007, the first earth-friendly Bible, printed on recycled, Forest Stewardship Council Certified paper, was offered by Christian publisher Thomas Nelson. This project was praised by the Alliance of Religions and Conservation (ARC), as the Bible is the most printed and widely distributed book in the world.

Judaism teaches that we should love God by loving all of his creation, and that nature is a gift from God for us to enjoy, use, and protect. The Coalition on the Environment and Jewish Life was founded in 1993 and seeks to further contemporary understanding of divine mandates such as or *tikkun olam* (repair the world), explaining that protecting nature and humanity is central in the Torah, and that working to thwart global warming is a mitzvah, or divine commandment.

Muslims are applying the Qur'an's teaching that God created *Al-Mizan* (nature in balance) and that humanity is charged with protecting this balance. The Africa Muslim Environment Network (AMEN) was formed in 2006, and advocates community development through sustainable use of the environment, based on the belief that the way forward for Muslim communities in Africa to take

responsibility for their future, and for the earth's future.

Buddhism emphasizes the importance of living simply and respecting all life, as Buddhists believe that all living beings are connected, and the health of the whole and its parts are inseparably linked.

Similarly, Hinduism views all plants and animals as sacred parts of God that should be honored and cared for. Hinduism stresses that true happiness comes from within, so the search for material possessions, and the consumption of materials and energy should not be allowed to dominate one's life. (Visit the ARC website at www.arcworld.org for environmental information on major world religions, including those not mentioned here.)

The focus on environmentalism in the context of religious tenets is growing among world religions, and this development will certainly have a very positive influence in our efforts to halt global warming. The challenge for all of us is to know, embody, and employ green values and teachings of our faith in our everyday lives. When we understand this, the seemingly mundane act of replacing an incandescent light bulb with a compact fluorescent bulb can be nothing short of enlightening!

Resources

- www.arcworld.org
- www.biggreenjewish.org
- www.christiansandclimate.org
- www.coejl.org
- www.environment.harvard.edu/religion/main.html
- www.pbs.org/moyers/moyersonamerica/green/index.html
- www.whatwouldjesusdrive.org

STEP #50
Teach Your Children

Our children—many of whom have a great chance to live until the end of this century—will inherit our warming world. The earlier our children understand and act on the issue of global warming, the better, but it requires careful consideration to best teach them about what can be a frightening and overwhelming issue.

Perhaps the best way to start—before trying to explain greenhouse gases and carbon footprints—is to ensure that your children have ample opportunity to understand and appreciate nature. This isn't best done through a computer monitor or TV screen, but by giving your children the chance to see salmon relentlessly push upstream against a strong current, or a sparrow build its nest on the ledge outside the bedroom window. It has been said that we can't save what we don't love, and helping your children build bonds with nature is the best way to get them thinking about and acting against global warming.

Consider planting a vegetable garden, flower garden or even a few seeds in planters with your children. The whole concept of life and growth becomes real when kids see it happening before their eyes. Make it an event to go to the store and let them choose their seeds. While you plant together, talk to them about the role of plants and trees in nature, including how they reduce CO_2 through photosynthesis.

Fast-growing crops like radishes, which are ready to eat in about 3 weeks, are great to start with. Children always

love flowers too, so be sure to plant some pretty ones. Visiting community gardens and farms, such as Halloween pumpkin patches or strawberry-picking fields, will open their eyes to the world of possibilities planting seeds offers. They'll love enjoying the fruits of the harvest, too!

Playing in natural environments will also raise kids' appreciation for the outdoors. How about playing hide and seek in a (safe) natural setting? The sense of awe experienced, in a redwood forest, for example is inspiring, especially to children. Fishing in a lake you've hiked to, having a picnic in a meadow, swimming and river rafting are all healthy ways for the whole family to enjoy the great outdoors together.

These fun experiences can make children all the more aware of the value nature has in our lives, spurring them to overcome the challenges of keeping our earth healthy. And since the fight against global warming is about saving ourselves as well as the planet, any experience that parents can help create to build their child's self-esteem and compassion for other living things will go a long way to giving that child the foundation for a happy and healthy life.

Author Richard Louv's book, *Last Child in the Woods: Saving Our Children from Nature-Deficit Disorder*, chronicles the retreat of America's youth from meaningful experiences in nature. He argues that the breaking of this bond with nature spawns an array of immediate and longterm problems for the mental and physical health of children and for the world they will inherit. He suggests a "No Child Left Inside" mindset among our families, organizations, and governments.

Despite our youth's growing concern about the environment, most don't understand how natural systems work, or how human actions and decisions are connected to pollution, global warming, and other environmental

impacts. The good news is that any daily activity can be a teachable moment for learning these dynamics and connections: driving to school, eating a burger, throwing away a wrapper, watching a plane leave a contrail overhead, turning on a light switch or a computer.

Of course, make sure that you are knowledgeable about these concepts and connections so that you can explain them well. Setting a positive example through your own decisions and actions as a parent goes a long, long way too. Richard Louv points out that modern media and even environmental groups might be doing more to discourage rather than empower children on global warming and other environmental issues of importance. He posits that messages children receive often have "it's too late" or "it's too big to solve" overtones and that this breeds hopelessness, indifference, and inaction among our youth.

While it's true that global warming is cause for alarm, we have to find ways to instill hope without candy-coating a real castor oil of a problem. A parent or teacher might point to the successes mentioned in the introduction of this book, such as how the world's cooperation on the phase-out of chlorofluorocarbons (CFCs) has reversed the growth of the stratosphere's gaping ozone hole. These examples can show children that it is possible to solve enormous problems, through policy as well as personal action. Even though this is a "grown up" topic, if explained the right way, even kindergarteners can understand it.

Since today's youth will be on computers, watching movies and TV, and hopefully reading a lot of books as well, we can be sure that their consumption of media helps to grow their knowledge and interest in the natural world and the plight of the human community. While watching an IMAX movie of polar bears or penguins isn't the same as bundling up and seeing them firsthand, these widely

accessible media do provide ways for children to learn to love and understand places and critters they may never see in person.

Thankfully, there is no shortage of resources for us and our children to learn about ecology, human-nature interaction, and global warming. One solid interactive Internet resource is the EPA's Climate Change site for children: www.epa.gov/climatechange/kids. Check out the site, but remember to head to the woods with your child after you log off!

Resources

- www.epa.gov/climatechange/kids
- www.kidsfootprint.org
- www.nwf.org/wildlifeandglobalwarming
- www.olliesworld.com

Appendix
The Green Patriot™
Green 100™ Companies

The following companies were selected because of outstanding achievement, progress, or profound affect on the marketplace through their efforts in ten key areas that reduce greenhouse gases, protect forests, and combat global warming. (For the specific criteria, visit www.greenpatriot.us/green100.html.)

American Formulating & Manufacturing	www.afmsafecoat.com
Affordable Internet Services Online, Inc.	www.aiso.net
Alcoa	www.alcoa.com
Advanced Micro Devices, Inc.	www.amd.com
Amy's Kitchen	www.amyskitchen.com
Aubrey Organics	www.aubrey-organics.com
Avalon Organics	www.avalonorganics.com
Aveda	www.aveda.com
Bank of America	www.bankamerica.com
Barlean's	www.barleans.com
BMW	www.bmw.com
Bosch	www.bosch.com
Bowater	www.bowater.com
BP	www.bp.com
Burgerville	www.burgerville.com
Centex	www.centex.com
Chevron	www.chevron.com

Chipotle Mexican Grill	www.chipotle.com
Chittenden	www.chittenden.com
Citigroup	www.citigroup.com
Clif Bar	www.clifbar.com
Coleman Natural	www.colemannatural.com
Co-op America	www.coopamerica.org
Dexia	www.dexia.com
Domini Social Investments	www.domini.com
Domtar	www.domtar.com
Dr. Bronner's Magic Soaps	www.drbronner.com
Earth Biofuels, Inc.	www.earthbiofuels.com
Eco Timber	www.ecotimber.com
Energy Star	www.energystar.gov
Esperanza Threads	www.esperanzathreads.com
Flora/Salus Haus	www.florahealth.com/ www.salus.de
Forbo	www.forbo.com
Ford	www.ford.com
Forest Stewardship Council	www.fsc.org
FreshDirect	www.freshdirect.com
Gaia Herbs	www.gaiaherbs.com
Gaiam	www.gaiam.com
Garden of Life	www.gardenoflife.com
GE	www.ge.com
General Mills	www.generalmills.com
GEOSOL	www.geosol.de
Global Exchange	www.globalexchange.org
Green Century Funds	www.greencentury.com
Greener World Media, Inc.	www.greenerworldmedia.com
GreenerPrinter	www.greenerprinter.com
Greenpeace	www.greenpeace.org
The Hain Celestial Group	www.hain-celestial.com

Herman Miller, Inc.	www.hermannmiller.com
Home Depot	www.homedepot.com
Honda	www.honda.com
Horizon	www.horizonorganic.com
Ikea	www.ikea.com
Intel	www.intel.com
Interface, Inc.	www.interfaceinc.com
International Paper	www.internationalpaper.com
Laura's Lean Beef	www.laurasleanbeef.com
LG Electronics	www.lge.com
Lifekind	www.lifekind.com
Lily Organics	www.lilyorganics.com
Linda Loudermilk	www.lindaloudermilk.com
The Lyme Timber Company	www.lymetimber.com
Maggie's Functional Organics	www.organicclothes.com
MicroPlanet	www.microplanet.com
Mitsubishi	www.mitsubishi.com
MyChelle Dermaceuticals	www.mychelleusa.com
Natural Resources Defense Council	www.nrdc.org
NaturaLawn of America	www.naturalawn.com
Nature Conservancy	www.natureconservancy.org
NatureWorks/Cargill	www.natureworks.com / www.cargill.com
Neil Kelly	www.neilkelly.com
New Chapter	www.new-chapter.com
Nike	www.nike.com
O'Naturals	www.onaturals.com
Organic Bouquet	www.organicbouquet.com

Organic Valley	www.organicvalley.com
Patagonia	www.patagonia.com
Pet Promise	www.petpromise.com
Quad/Graphics	www.qg.com
Rainforest Action Network	www.ran.org
Recycline	www.recycline.com
RR Donnelly	www.rrd.com
Samsung	www.samsung.com
Seventh Generation	www.seventhgeneration.com
Shell	www.shell.com
Shore Bank	www.shorebank.com
Sierra Club	www.sierraclub.org
Starbucks	www.starbucks.com
Stonyfield—Danone	www.stonyfield.com
Sun & Earth	www.sunandearth.com
Sun Frost	www.sunfrost.com
Target	www.target.com
Timberland	www.timberland.com
Toyota	www.toyota.com
Trader Joe's	www.traderjoes.com
Uni-Solar	www.uni-solar.com
Vestfrost	www.vestfrost.com
Virgin Airlines	www.virgin-atlantic.com
Waste Management	www.wm.com
Whole Foods Market	www.wholefoods.com
World Wildlife Fund	www.wwf.org

If you would like your company or organization to be considered for the Green Patriot Green 500™, please visit www.greenpatriot.us/green100.html.